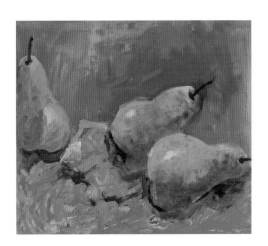

Dynamic
Acrylics

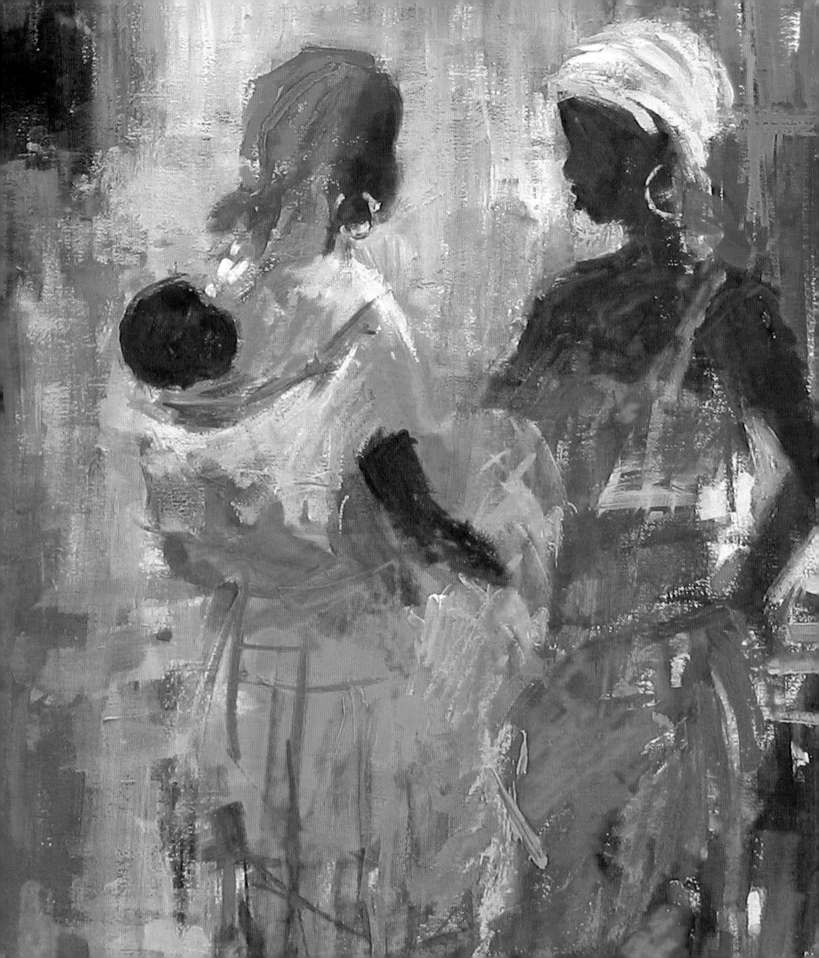

Collins · *artist's studio*

Soraya French

Dynamic Acrylics

First published in 2009 by
Collins, an imprint of
HarperCollins*Publishers*
77-85 Fulham Palace Road
Hammersmith, London W6 8JB

The Collins website address is: www.collins.co.uk

Collins is a registered trademark of HarperCollins Publishers Limited.

13 12 11 10 09
6 5 4 3 2 1

A catalogue record for this book is available from the British Library

Editor: Caroline Churton
Designer: Kathryn Gammon

ISBN 978 0 00 728644 7

Colour reproduction by Colourscan, Singapore
Printed and bound by Leo, China

page 1: **Three Pears**, 35.5 × 35.5 cm (14 × 14 in)
page 2: **African Women**, 40.5 × 35.5 cm (16 × 14 in)

Dedication
To the memory of my beautiful sister Djaleh

Acknowledgements
My thanks and gratitude to all the participating artists for their
invaluable contribution.

I would also like to thank Cathy Gosling and Caroline Churton
for initiating this book, and Laura Kesner and the team at
HarperCollins for helping to put it together. Thank you to
Caroline for her continuous guidance and support, and her
wonderful and sympathetic editing, and to Kathryn Gammon
for her brilliant design work. I am also grateful to Sally Bulgin
and Caroline Griffiths at *The Artist* magazine for their
friendship and support throughout the year.

My love to Tim, Jazz and Saasha – thanks for putting up with
me. To Dad – this book is for you.

Soraya French is featured in a new instructional DVD also
called *Dynamic Acrylics*. It is available from Town House Films
on 01603 281007 or www.townhousefilms.com

Contents

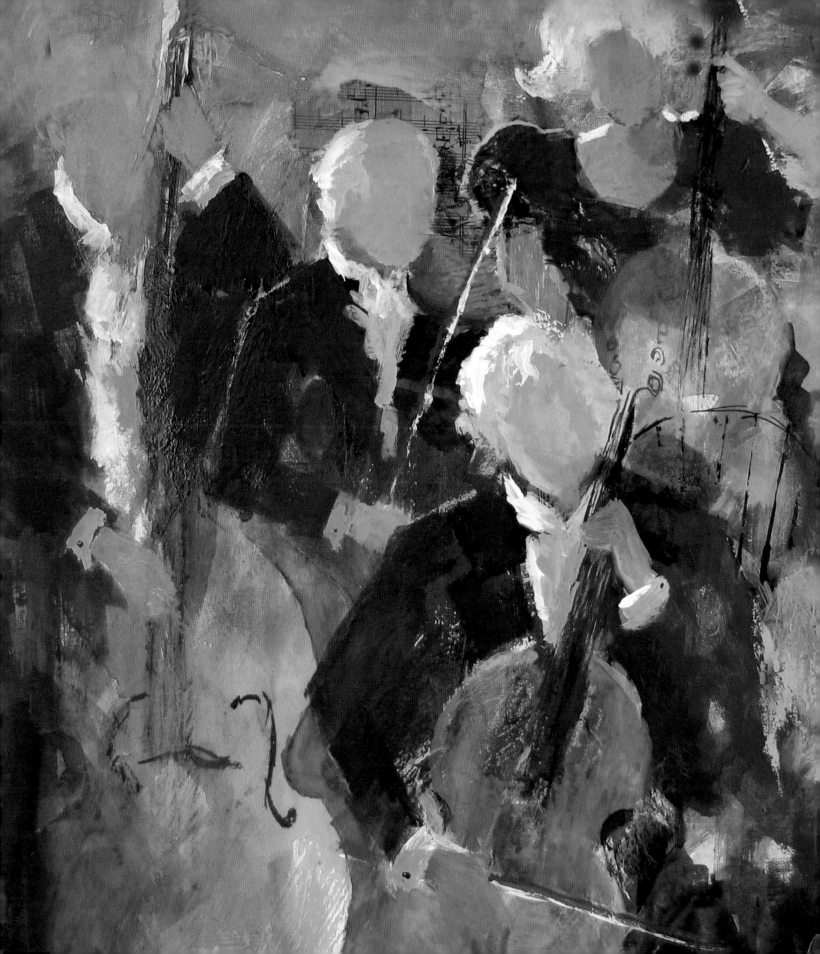

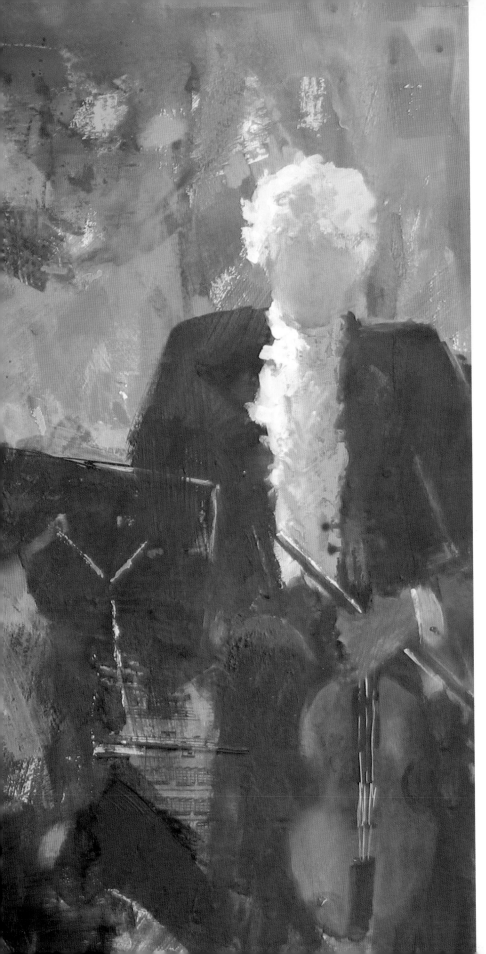

Introduction

As painters we are challenged at every turn by both the technical aspects and the creative thought processes that contribute to the development of our paintings. A forgiving and versatile medium such as acrylics that is not in itself too challenging is therefore a great tool to enable both the newcomer and the more experienced artist to process their thoughts and ideas with more confidence.

At long last acrylics have found their rightful place alongside the other major painting media, such as oils and watercolours. Today we have some of the best-quality acrylics available to us, and with fresh and innovative ideas being introduced all the time we can look forward to yet more exciting developments. I hope that by the end of this book you will have discovered the joy of acrylics for yourself, and will share my passion and enthusiasm for this amazing and wonderful medium.

◁ **Waiting for His Turn**
40.5 × 51 cm (16 × 20 in)

The artist's vision

'An artist with no vision is a locked treasure chest with no key.' (ANON.)

There is a vast difference between merely being able to paint and being an artist. The latter has the ability to turn the ordinary into something extraordinary. An artist's vision is his or her ability to interpret what they see in a unique, individual and original way. This is partly an intellectual exercise and partly intuitive. A few people are naturally gifted, but for most it is a matter of lifelong commitment and a relentless although highly enjoyable learning process combined with instinctive ability. There is a dormant artist within everyone, and for those who are lucky enough to have the motivation and the opportunity to tap into and discover the creative part of their being a wonderful world awaits.

There is sometimes too much emphasis on the technical aspects of painting rather than on encouraging and nurturing the artist's personal vision. However, if the desire and the spark of inspiration are there, with perseverance and practice you will find that in time your ability to think creatively will grow and your individuality will shine through in your work.

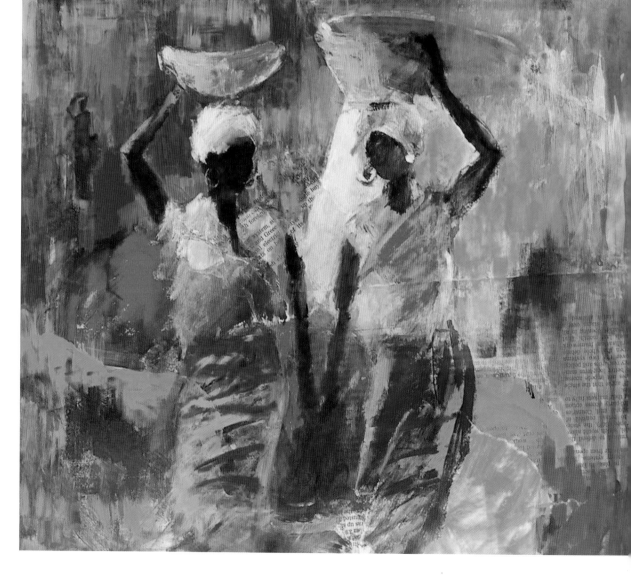

▷ **Daily Chores**
30 × 30 cm (12 × 12 in)

This painting marks the beginning of a series of works with which I felt more at home and comfortable in my approach, with regard to subject, colour and style.

Breaking inhibitions

As children we were encouraged to be neat and tidy in all tasks, earning praise for precise drawing and for keeping colours within outlines. Breaking these ingrained habits as adults is quite a daunting task, but one that can certainly be achieved if you really wish to move forward with your painting. To do this successfully you need to step outside your comfort zone and be prepared to take some risks.

A high percentage of amateur artists take up painting later in life, by which time they are often quite set in their ways, but it is still possible to learn new habits if the inclination is there. My workshops regularly attract students who wish to break free from detailed and overworked paintings.

Sound drawing and observational skills are absolutely necessary foundations for painting, but

are best done as a separate exercise. A well-executed drawing can become too precious and therefore inhibiting, so when painting try to keep any preliminary drawing to just the minimum outlines – or better still, make no drawing at all. Break down the subject to mere shapes and tones, blocking them in with acrylic inks or paints to begin with and ignoring all the details. Using big flat brushes will help you to do this.

A forgiving and highly flexible medium such as acrylics, which offers both translucency and opacity, is great for breaking down inhibitions and giving you the opportunity to experiment with more confidence. You may also find that the changes you make in your artistic life spill over to your personal life, broadening your attitudes and helping you to break free from some of the rigid rules that we so often impose on ourselves.

△ **Italian Rooftops**
46 × 66 cm (18 × 26 in)

I started this painting, inspired by a sketch of Florence, by randomly applying pieces of collage. I then added washes of acrylic ink, taking advantage of the happy accidents that occurred through the merging of colours. Heavy-body acrylics applied with a roller were used to break up the shapes and an old credit card dipped in ink was used to define the shapes of the rooftops.

▷ The artist at work in her studio in Hampshire, which is open to visitors all year round.

A personal approach

Although my formal education was not art related, as far back as I can remember painting and drawing have been a big part of my life. I quickly realized after I went back to painting as an adult that this was going to be a never-ending journey of discovery, one during which I could choose to take either the safe, undemanding way or a more exciting and adventurous route. This book includes both old and new paintings to show how I have evolved as a painter. I am not art school-trained, but I detest the phrase 'self taught' with a vengeance. I believe that our whole life is shaped by what we learn from the hard work and experiences of those who have gone before us, as well as our peers, and I feel that I have had my fair share of generous advice, for which I am eternally grateful.

When I was in my late twenties I was lucky enough to stumble upon an experimental workshop with less emphasis on technique but a great deal of concentration on the thinking process behind painting. At the time I found this frustrating, but in hindsight I realize that it totally changed the way that I perceive art and the creative process of painting. I was left to my own devices in order to find my way and discover who I was as an artist, and this has influenced the way I go about teaching my own students. My aim is not to produce clones, but to bring out the individual artist which already exists within each and every one of them.

I regard my work as painting in progress. My personal approach is experimental and I am not frightened by failures. I keep them as a reminder of what went wrong so that I can learn from them or I rework them as new paintings. I love all painting media as each one offers a unique quality. However, in acrylics – both as a medium in its own right and when mixed with other media – I have found my artistic soul mate, and discovering this was a huge turning point in my life as a painter. I feel blessed to be doing something I am so passionate about on a daily basis, and my art and all that is related to it has enriched my life beyond my wildest dreams.

▷ **Persian Folk Dancers**
33 × 43 cm (13 × 17 in)

It was after one of my trips to my homeland many years ago that I was struck by the bright colours worn by the tribal women. My love of clashing and vibrant colours must be part of my heritage!

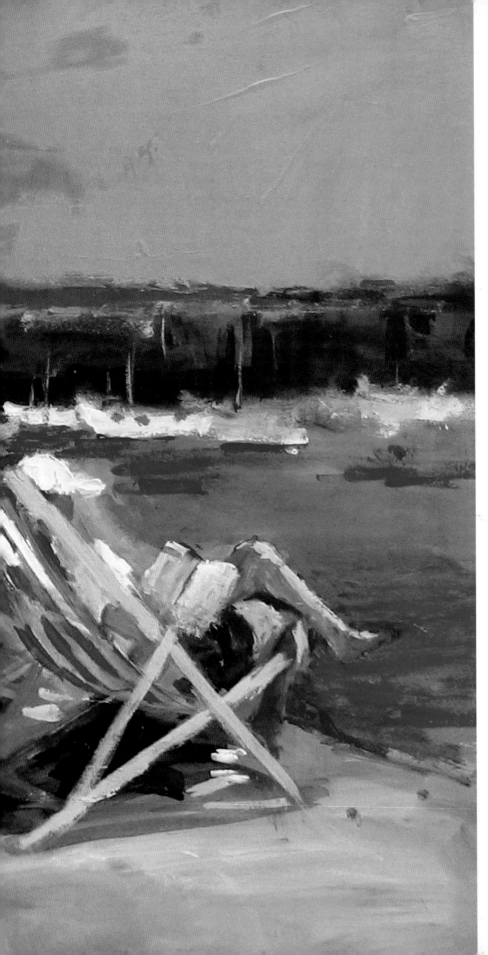

Exploring acrylics

Acrylic paint is available in a number of different forms and consistencies – indeed, this is one of its attractions, as the results that can be achieved with the medium are so varied. Because of this, however, acquiring an initial set of acrylic materials can be rather daunting for artists new to the medium. The number of tubes, jars and mediums is simply staggering and can be very confusing.

In this chapter you will find all the information you need regarding the various forms of acrylic paint and this should help you to decide which are most suitable for your personal way of working. The simplest advice I can offer you is to invest in the best-quality paints you can afford, as these will help rather than hinder your progress.

◁ Deck Chairs
23 × 30 cm (9 × 12 in)

Acrylic colours

Acrylics are water-based, odourless and flexible, and the most versatile medium available to artists. Their fast-drying nature encourages spontaneity and means that there is very little need for the kind of forward planning that watercolour painting requires. Traditional acrylics are generally mixed on a stay-wet palette to prolong the time they remain workable. However, the recent addition of a new type of acrylics with an extended working time, which makes blending and softening of edges easier, has broadened the already extensive range of transparent and opaque techniques that are possible. Artist-quality paints have all the necessary details regarding opacity, transparency and other relevant information written on the tubes, to help you to choose the right kind of pigment for your purposes.

The next few pages should familiarize you with some of the attributes of this wonderful medium and help you to select the type of acrylic colours to suit your style of painting. Each has its own characteristics and produces different effects, so take some time to discover these so that you will be able to use them confidently in your work.

▽ **Harbour Patterns**
35.5 × 35.5 cm (14 × 14 in)

This painting, with a textured ground made from tissue paper and printed text, reveals the vibrancy of acrylic colours. Washes of Payne's Grey and Flame Red acrylic inks were used for the background, and then the buildings and boats were painted with heavy-body acrylics, in tints of Magenta, Ultramarine Blue, Dioxazine Purple and Yellow Ochre.

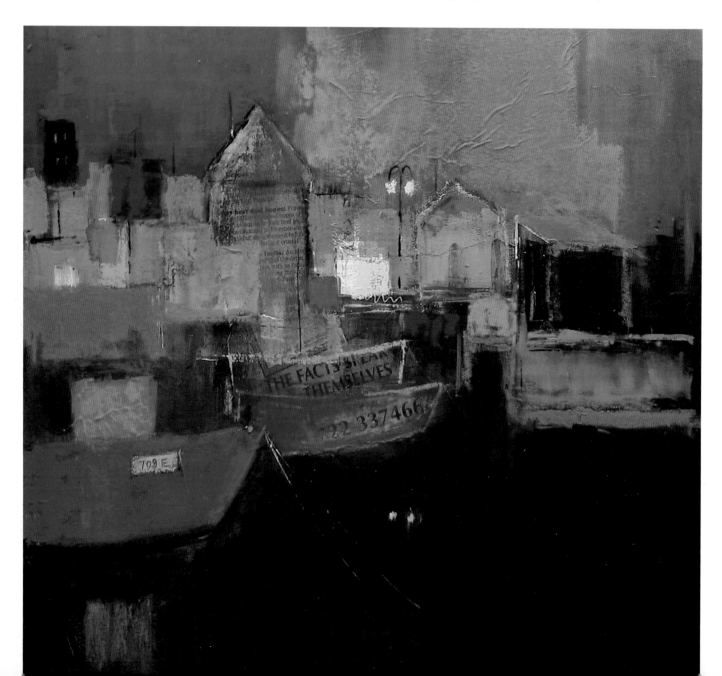

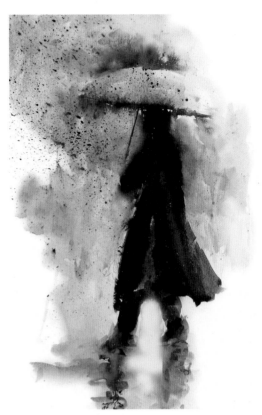

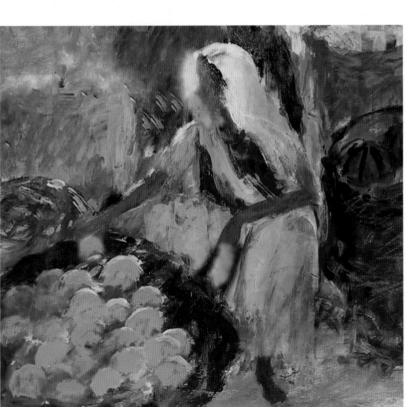

◁ **Rushing Home**
30 × 25.5 cm (12 × 10 in)

For this quick and spontaneous figure study I used Payne's Grey and a little Turquoise ink, adding the faintest wash of Process Magenta for warmth. I spattered neat ink over the painting at the end to suggest the rainy atmosphere.

▽ **The Fruit Seller**
25.5 × 20 cm (10 × 8 in)

Soft-body acrylics are perfect for little sketches such as this. They are thicker than acrylic inks, with more covering power. Here I used the colours quite neat, with only a little water, and applied them with a damp brush.

Acrylic inks

Acrylic inks are the most fluid form of acrylics. These fabulous colours are made of artist-quality pigments dispersed in acrylic resin and therefore are highly permanent, unlike dye-based watercolour inks, which can be prone to fading. I use Daler-Rowney's range of FW inks, which are widely available.

Acrylic inks come in a superb range of both opaque and transparent colours, and a glance at the bottle will give you all the information you need in this regard. The wonderful colours mix well together and are intermixable with tube colours as well. Mica-based inks, which have a shimmering, iridescent effect, are also available.

You can paint beautiful, vibrant, watercolour-style paintings with these inks, or you can apply initial washes of ink followed by thicker acrylic colours to create more textured areas. As the washes of colour dry to a waterproof film subsequent layers do not disturb each other, so the colours retain their freshness and vibrancy. It is also possible to glaze an area of heavy-body acrylics with inks at the later stages of a painting to knock back or enhance the colour.

Soft-body acrylics

Soft-body (or flow-formula) acrylic colours have a low viscosity and therefore a smooth and free-flowing consistency. They tend to spread on the palette and do not retain brush marks, and for this reason they are great for diluting and using in watercolour techniques. When dry the paint seems to sink back so quite a number of layers are needed to build up any kind of texture. To achieve this it is best to use soft-body acrylics quite neat with a merely damp brush, or you can add an impasto gel or gel extender to them to create a heavier consistency.

Most student brands are soft-body acrylics; they are more economical as they are usually both uniformly and reasonably priced. Student-quality acrylics contain less pigment and more binder to add bulk so do not expect them to have the vibrancy and performance of artist-quality paints. If you choose to use artist-quality soft-body acrylics Golden's range of Fluid paints offers fabulous and intense colours.

Heavy-body acrylics

Heavy-body (or high-viscosity) acrylic colours have a heavier consistency than soft-body acrylics and have great covering power. They are also easier to layer and good for creating texture in a painting. There are both transparent and opaque colours within the range, and they are intermixable with acrylic inks and the soft-body colours. They can also be further thickened with an impasto gel or gel extender.

They can be diluted with water for washes of colour if necessary, although this will result in a loss of colour saturation. If they are used for oil painting-style techniques it is best to use just a little water and plenty of pigment for successful layering of colours. For less wastage, mix them with a palette knife.

▽ **Bag of Tomatoes**
20 × 25.5 cm (8 × 10 in)

Two layers of heavy-body acrylics, with their excellent covering power, were used to build up the roundness of these tomatoes. I used Titanium White for the highlights on the polythene bag over a background of grey tones.

Superheavy-body acrylics

Superheavy-body acrylics have a much heavier, buttery consistency and retain brush strokes and palette knife marks. They are most suitable for impasto-style applications, although they can be diluted and used as washes of colour should the need arise. The extra-strength viscosity allows for highly interesting textural effects, and there is no need for gel medium to increase their consistency. They also mix well with other types of acrylics.

◁ **Sunflower**
20 × 20 cm (8 × 8 in)

The thickness of superheavy-body acrylics was ideal for giving the flower its three-dimensional form. I used a painting knife for this little study.

▷ **Apple Study**
15 × 15 cm (6 × 6 in)

This little study was done on canvas. Thicker acrylics work better on this surface: use only a little water and plenty of pigment.

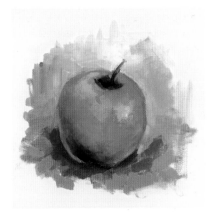

◁ **Cockerel**
15 × 15 cm (6 × 6 in)

I used heavy-body acrylics on watercolour paper to paint the cockerel and washes of acrylic ink for the background. If you use inks with lots of wet washes on a lightweight watercolour paper it is best to stretch it first.

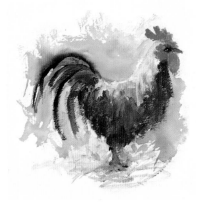

▷ **Lemons**
18 × 20 cm (7 × 8 in)

I used thicker paint on acrylic paper for this study. Thinner layers of colour pick up the texture of the paper.

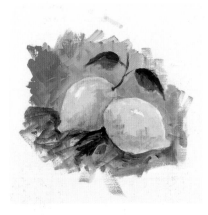

◁ **Poppy**
24 × 13 cm (9½ × 5 in)

For this little sketch I used washes of acrylic ink on mountboard. When applied to a surface that has not been primed with gesso the first layer sinks in and creates a non-porous surface as it dries.

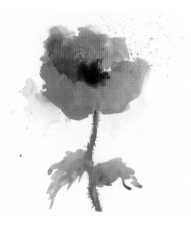

Surfaces

When painting in acrylics there are two surfaces that are best avoided – a shiny surface and an oil-based or greasy one. Acrylic paint turns into a plastic film when it is dry and it will peel off both these surfaces. All of the following supports are good to use, but take note that each one will create a totally different effect when paint is applied – no two surfaces will give you the same result. Most artists find that one or two suit their style of painting and use these for all their work.

Acrylic paper: slightly textured and generally quite lightweight, this paper works best with thicker applications of paint that require less water. It is great for opaque techniques, particularly the dry-brush technique, scumbling and layering of colour.
Watercolour paper: most watercolour papers are suitable for use with acrylics, and they can be used with or without gesso. Their advantage is that both thick and thin applications are possible, with equally good results.

Canvas and canvas boards: on these supports it is best to use the paint thickly with very little water and to build up layers of colour. Acrylic mediums are especially useful for this. Canvas is ideal for impasto-style work and all the oil painting techniques.
MDF (medium-density fibreboard): this board is available in varying degrees of thickness and if primed with two coats of gesso is a very economical surface for painting in acrylics.
Mountboard: good-quality mountboard can be used with or without gesso. Both thick and thin paint applications work equally well on this surface.
Cardboard, card, grey board and pulp board: these can all be used with acrylics, but they work best once they have been primed with two layers of gesso.

Explore further

- Paint the same picture on a variety of different surfaces and make a note of the results for future reference.

Acrylics with extended working time

Despite the many great attributes of acrylic colours, the fast-drying nature of the paints can prove something of a disadvantage for some artists. One of the leading manufacturers of acrylic colours, Golden, has recently introduced a range of new and revolutionary acrylics called OPEN, which have an extended working time. This feature expands the already wide range of possible techniques using acrylics and facilitates methods such as blending, glazing and softening of colours. They are ideal for any oil painting techniques that rely on working into wet paint and are particularly useful for subjects such as portraiture. The best feature of the paints is their ability to stay wet and workable on an ordinary palette without any special treatment for days on end.

There are several mediums in the OPEN range. Acrylic Gel (Gloss) is formulated with the same consistency as the colours and is used to extend the paints while maintaining their working properties. Acrylic Medium (Gloss) has a runnier consistency and is used to extend paint and maintain properties when a more fluid mixture is needed to increase flow. OPEN's Thinner contains no binders and is used either to thin the consistency of paint mixes without altering the working time, or to maintain and adjust the workability of colours on the palette without the use of a fine mist of water.

Using the paints

The drying time of a painting depends on how thickly the paint has been applied. With OPEN acrylics, unlike oil colours, should you need to speed up the drying time you can apply thinner layers, use a hairdryer, or mix fast-drying Titanium White or gloss or matt mediums with the paint.

OPEN acrylics mix well with normal heavy-body acrylics, gels and mediums, but the length of time the mix will remain workable will reduce according to the ratio of fast-drying colours included. If you use both fast-drying and OPEN acrylics in one painting, make sure you apply the fast-drying colours either in the lower layers or over the top of already dried OPEN acrylics.

These innovative acrylics give you the best of both worlds: they can either stay wet or dry quickly on your support; and they stay wet and workable on your palette, reducing paint wastage enormously.

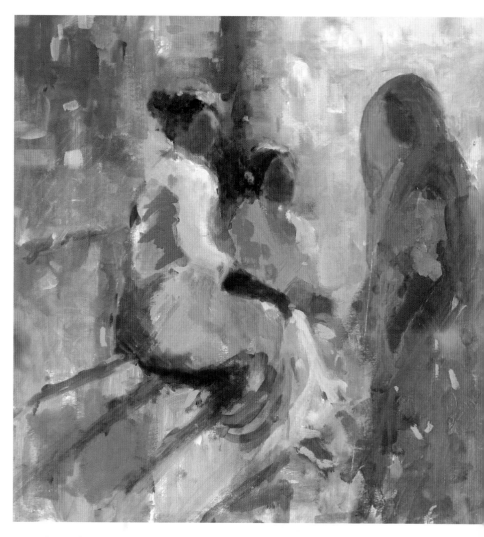

△ **Nepalese Girls**
30 × 30 cm (12 × 12 in)

OPEN acrylics were used for this painting. It was great to be able to manipulate the paints for longer to get the desired effects, especially when blending the skin tones and shading the colours of the background and the garments.

Studio tips

- Although OPEN acrylics stay wet and workable on your palette for days, by applying a fine mist of water and covering them after your painting session you can extend this to weeks.
- In order to keep ordinary acrylics wet and workable, use a stay-wet palette. To make a surface ready for your paints, line a shallow plastic box, which has a lid, with damp kitchen towel and lay damp grease-proof paper over the top. Spray the paint on the palette with water from time to time as you work and replace the lid at the end of your working session.

Gesso

Gesso is an acrylic-based primer which can be applied to seal and prepare an absorbent or semi-absorbent surface for painting with oils or acrylics. Whereas priming the surface is essential for oil painting, it is optional when painting in acrylics.

Gesso is available in black and white, and it dries to a chalky finish with a slight tooth. It can be applied with heavy brush marks to create a textured surface or it can be sanded down to an even, smooth surface for highly detailed and glazing techniques. Both inks and soft-body acrylics can be added to gesso to make a coloured ground for painting.

A surface which has been primed with gesso and is therefore non-porous will produce totally different results from an unprimed and absorbent support. Colours sink into an absorbent surface, unlike on a primed one where they usually look more glossy and mix together to create lovely effects. Golden has a product called Absorbent Ground, which produces a surface similar to that of watercolour paper and gives superb results. When applied to canvas or board it creates a surface that is suitable for washes of acrylic ink.

Varnish

Pure acrylic paintings on board or canvas can be framed without glass in the same way as oil paintings. However, the soft and spongy surface of acrylic colour attracts dirt from the atmosphere easily, so to protect it from the environment and increase the longevity of your painting it is advisable to apply two coats of acrylic varnish. Should you need to restore the painting later, the varnish can be removed along with any surface dirt.

You can buy both gloss and matt varnish. Gloss varnish deepens and intensifies the colours, whereas matt varnish decreases glare, and both consolidate the painting with an even sheen. A top-quality varnish, such as the one produced by Golden, also protects against ultraviolet rays generated from the sun.

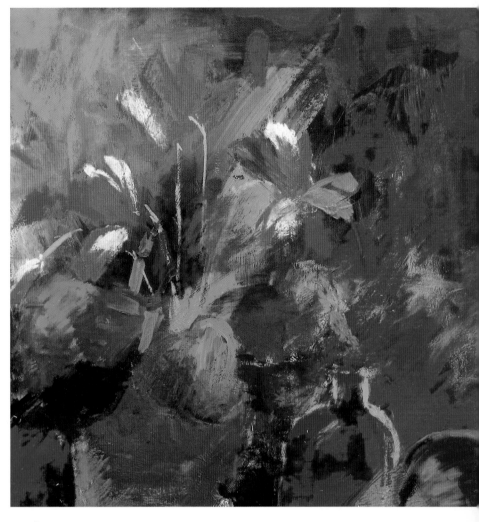

△ **Cyclamen**
35.5 × 35.5 cm (14 × 14 in)

For this painting I used card as my support, with two coats of gesso applied vigorously to show the brush marks. When I added the paint afterwards I allowed some of these early gesso brush marks to show through, adding texture to the painting.

Studio tips

- Keep all your paintings that for some reason were not successful. You can cover the surface with gesso so that you have a blank canvas or piece of paper to be used again.
- Keep your brushes in water while you are working, but rinse and dry them when you finish. Use a small amount of conditioner from time to time to keep them supple.
- Remember that the amount of water you use with acrylics is very important – not too little for washes of colour or too much for opaque techniques.

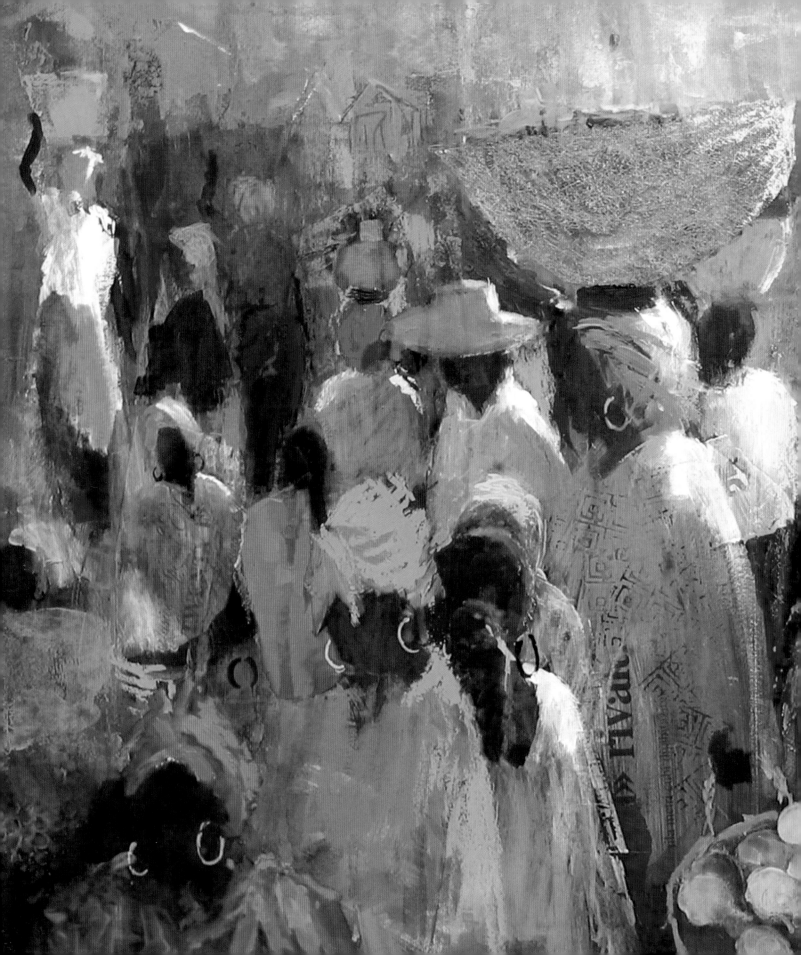

Applying acrylics

Acrylics are the chameleon of painting media. They can mimic both watercolours and oils, but they also have unique characteristics of their own with surprisingly exciting effects that are not possible with either of those other media.

One of the greatest advantages of working in this wonderful medium is the lack of rules and restrictions when it comes to using it. Highly permanent and durable, the paints can be applied thickly or thinly, in any sequence, and on numerous surfaces without compromising the result or the longevity of your painting. Whether you wish to work in a traditional style or in a more contemporary way, this versatile medium will enable you to explore new and exciting avenues, and to create truly dynamic paintings.

◁ Caribbean Market
46 × 56 cm (18 × 22 in)

Watercolour-style washes

Acrylic colours can be diluted with water and used like watercolours, applied either wet-into-wet or wet-on-dry. Once dry, acrylics are waterproof, so you can build up layers of colour more easily and without previous washes being disturbed.

Wet-into-wet

Wet-into-wet washes of colour provide a smooth transition of one colour into another, which creates beautifully soft and diffused edges. They are a great way of capturing mood and atmosphere in a painting. The already fluid acrylic inks are ideal for this technique, but you can also use dilute soft-body colours. A drop of retarder will prolong their working time. It is crucially important to get the balance between the wetness of the paper, the amount of water on the brush and the pigment in it exactly right for successful wet-into-wet washes of colour.

When working with acrylics in this way it is best to use an absorbent surface, such as watercolour paper. Alternatively, you can prime canvas or board with Golden's Absorbent Ground gesso.

Wet-on-dry

Working wet-on-dry creates crisp, hard edges and is one of the most common ways of applying watercolour-style washes. This technique can be combined with wet-into-wet washes to provide more variety and interest in your paintings.

Glazing

The fast-drying nature of acrylics makes them ideal for this technique. Acrylic inks are superb for glazing, but tube colours can also be diluted and applied as a glaze. Matt or gloss medium can be quite useful here as it improves the flow of colours and maximizes their intensity.

To apply a glaze, a thin transparent layer of colour is painted over another layer of transparent, opaque or thicker dried paint. This achieves maximum depth and richness of colour. It is important to let each layer dry before you apply the next glaze. You can also apply a thin glaze of blue over paint applied in the impasto style to make selected elements in the painting recede.

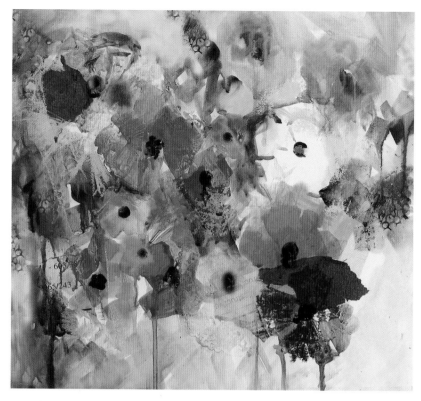

△ **Anemone Fusion**
35.5 × 35.5 cm (14 × 14 in)

Here the colours of the anemones were flooded on to the wet surface of watercolour paper with acrylic inks. This was then moved around to allow the colours to fuse into one another. When it was dry, the flower shapes were painted wet-on-dry to create some harder edges, while at the same time leaving some of the softer edges in place.

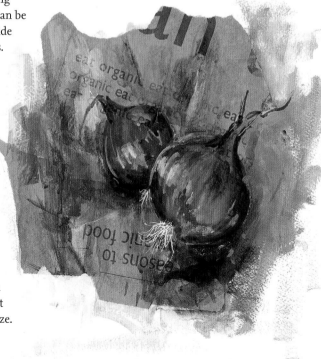

◁ **Organic Red Onions**
25.5 × 28 cm (10 × 11 in)

Thin glazes of Quinacridone Magenta soft-body acrylic and Flame Red and Flame Orange acrylic inks were built up to create the rich colour of the onions. For the deeper areas of colour I used neat glazes of Purple Lake ink. Glazes of white acrylic ink provided the highlights.

Sgrafitto

In this technique a sharp tool, such as a sculptor's modelling tool or even the end of a paint brush, is used to scratch out a linear design in a layer of wet paint that has been applied over dried paint of a different colour. This is great for creating the tactile textured effect of subject matter such as the weave of a basket or the bark of a tree, or simply a rhythmic abstract pattern in a painting. For your underpainting, choose either a complementary colour or one that is lighter than the top layer of paint. OPEN acrylics, with their extended working time, are particularly suited to this technique as the colours stay wet much longer, allowing enough time for the pattern to be created.

▽ **Persian Landscape**
35.5 × 38 cm (14 × 15 in)

I applied heavy-body acrylics over an underpainting of Flame Red ink. Then I scratched out linear patterns with the end of my brush to give the impression of the plants in the field.

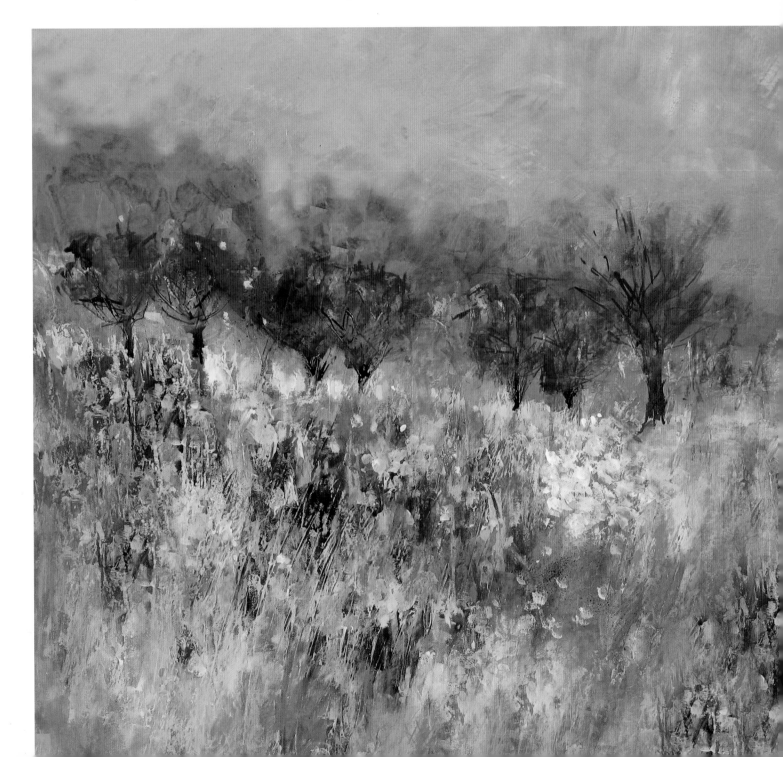

Impasto style

Impasto refers to the style of painting in which the paint is applied in thick layers so that it is slightly raised from the surface. Superheavy-body acrylics are most suitable for this technique as they naturally retain brush and palette knife marks, although heavy- and soft-body colours can be made thicker with the addition of gel or impasto medium. A palette or painting knife is ideal for this technique

as the random marks they make, together with the thick, raised layers of paint, create an invigorating surface that has a certain energy about it. Fast-drying colours are best for this style of work.

Using a combination of thinner washes of acrylic colour in the background and the impasto technique in the foreground is very effective in creating depth in a painting. Van Gogh was a master of the impasto style and contemporary artist Frank Auerbach uses this technique to perfection.

▽ **Sunflowers**
40.5 × 40.5 cm (16 × 16 in)

I first applied washes of ink and some collage, then used a painting knife to build up thick layers of heavy-body acrylics for the flowers and background. A few areas of the initial washes were left untouched to create a sense of recession in the painting.

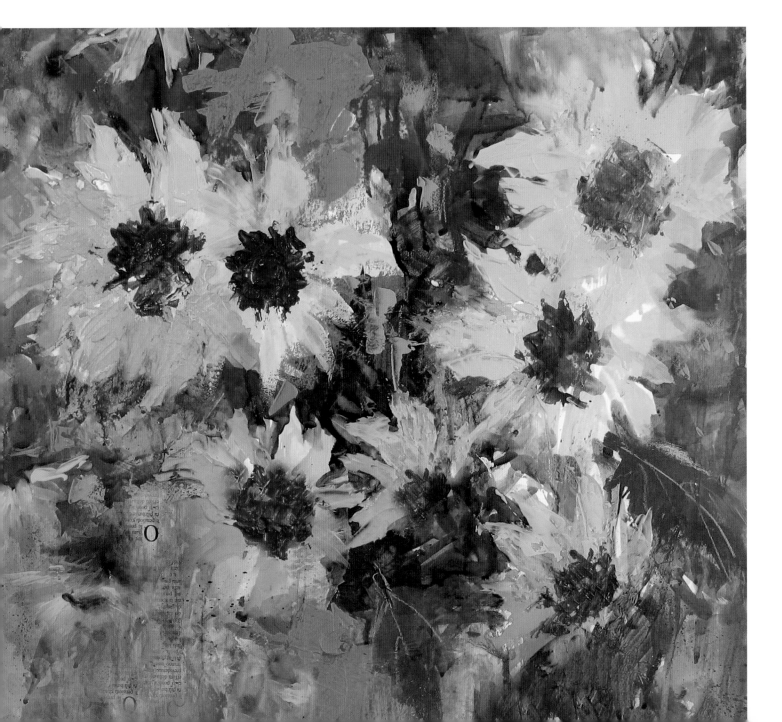

Scumbling

Superimposing an opaque layer of colour over a painted area in a loose and free manner is known as scumbling. It is similar to the dry-brush technique in that the lower layer shows through the subsequent scumbled layers, producing a broken-colour effect. The paint is applied fairly dry with either a barely damp acrylic brush, rag, sponge or fingers. You can achieve beautiful textural effects, such as the shimmer of hazy light, clouds, glass windows or, as shown here, the semi-transparent seed-heads of honesty. Alternatively, it can be used simply to tone down an area of colour.

◁ **Bluebells**
30 × 25.5 cm (12 × 10 in)

Here almost dry pigment was brushed on to the smooth gessoed surface, creating a hazy ground in neutral tones. The bluebells were added with heavy-body acrylics and their stems were scratched out with a sharp tool.

▽ **Honesty and Anemones**
25.5 × 25.5 cm (10 × 10 in)

Here I applied almost dry layers of Unbleached Titanium and Yellow Ochre to convey the luminous transparency of the honesty seed-heads. Scumbling with opaque layers of colour was used to put in the white and purple anemones.

Dry-brush technique

The dry-brush technique, in which paint is applied with very little or no water, produces quite atmospheric results. The lack of water maximizes the adhesive quality of acrylics which means that the colours layer beautifully, and as the paint dries rapidly you can apply subsequent layers in quick succession. You can use both inks and heavy-body acrylics in this way.

The hit-and-miss effect of the technique creates areas of broken colour so that some of the colours from the lower layers show through, giving the illusion of depth in a painting. When used on rough paper this technique is very effective in portraying gravelly or stony ground and, by allowing the white of the paper to show through, creating the sparkling highlights on water.

Painting with other implements

A brush is not the only implement for painting. Sometimes brush marks can become slightly stylized and can compromise the surface quality of a painting, but you can overcome this by using another tool to paint with. Twigs and sharpened sticks are great for drawing with ink – the uneven lines they produce are very lively and attractive. Other items you can use for more interesting mark making include your fingers, a sponge, a rag, a roller, a palette or painting knife, and even an old credit card. All of these will create variety in the surface finish of your painting.

Using a roller

Applying paint with a roller is such a liberating way of working – it is almost impossible to achieve any kind of detail, which results in a much looser style of painting. The paint is applied in a hit-and-miss manner that is very attractive. If you do not wish the white of the paper to show through, you can apply an underpainting in acrylic inks or diluted colour prior to using the roller.

Use a flat tray to load the roller with paint. It is best not to rush subsequent layers of colour – let each one dry before applying the next to avoid muddy colours. Depending on your subject, you may find that you need to add one or two details with a brush or other implement to pull the painting together.

△ **Stripy Towel**
35.5 × 35.5 cm (14 × 14 in)

This painting was done over a coloured ground of blue, turquoise and red acrylics, and the girls were painted entirely with a roller. As the paint went on quite thin and flat in a random manner, the final effect is less stylized and relies on a few happy accidents. A rigger brush provided a few finer marks to finish the painting.

Studio tips

- Using a roller, painting knife or an old credit card as well as your brushes can really enhance areas of your painting and add variety to the mark making.
- Attaching a pencil to a long stick and using this to draw on paper placed on the ground is a great way to loosen up your work.
- If you plan to use a lot of water when working in the wet-into-wet style, make sure that you stretch the paper first, as for watercolour painting.

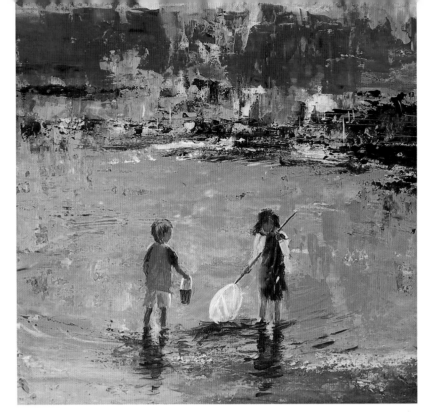

Painting with a card

Scraping paint with an old credit card or a similar tool produces really lovely flat areas of colour. Once the initial layer of paint is dry, using a card to superimpose other colours can be a very effective way of building up the surface. The scraping action results in thinner layers of paint, which allow some of the colour from underneath to show through.

The edge of the card, dipped into ink or paint, can also be used to draw the horizontal and vertical lines of a building or any other elements in the painting with defined edges. The resulting lines are quite different from those made with a brush, making this method particularly suitable for a more contemporary style of painting.

Using a palette or painting knife

There is a wide range of palette and painting knives available, and the two are often mistaken for one another. A palette knife has an elongated blade and is normally used for mixing colour on the palette. Painting knives come in all shapes and sizes and are used as an alternative to brushes for painting; the smaller the blade the more precise the mark it makes. Both palette and painting knives can be used for mixing colour and painting.

A painting knife leaves flat and random marks, and is great for abstracting areas of colour. Depending on the shape of your painting knife you can use it to scrape large areas of colour or to enhance an area with accents of colour. Make sure that the lower layers are dry or you might end up with mixes of colour that can be visually distracting. If you need to layer paint more quickly, you could always use a hairdryer to speed up the drying process. A painting knife is also the ideal tool for impasto-style painting.

△ **Children Fishing**
30 × 30 cm (12 × 12 in)

Here layers of Ultramarine Blue and Light Blue Violet acrylics were scraped with an old credit card over a neutral grey background. I used a No. 4 flat brush to paint the children as I did not want to include any detail on them.

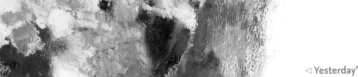

◁ **Yesterday's Paper**
25.5 × 20 cm (10 × 8 in)

I used a painting knife here to apply heavy-body acrylics over a collaged surface. I scraped the paint in the background to create thinner layers, but for the pot and the petals used thick, random marks. Washes of Prussian Blue ink applied with a brush in between the flowers create depth.

PROJECT Mark making

This project looks at alternative ways of mark making to enhance your paintings and create abstract or semi-abstract passages. Materials such as sequin relief, sponges, netting, coins, stencils or stamps and techniques such as spattering produce unusual and eye-catching effects. Marks made by these means can be either totally abstract or they can represent the texture of the subject matter. For example, an imprint of bubble wrap dipped in paint and pressed on to the painting surface can be left purely as a visually pleasing area of texture or it can represent round fruits in a market scene. Marks such as this look random and effortless, making them more interesting than similar patterns created with a brush, which can often result in stilted and stylized texture.

For this project, choose a subject such as flowers, a landscape or a market scene and incorporate some of the mark-making techniques mentioned here into your painting. Alternatively, revitalize an old painting with one or two of these methods. The key to using these techniques successfully, however, is not to overload one image with too many of them.

Skeleton leaves
Skeleton leaves are available in all shapes and sizes. Their textured surface can be painted and then pressed on to a painting either to represent foliage or to create an abstract effect. They are great both for use in collage and for leaving impressions. Real leaves can also be used in the same way.

Sequin relief
Sequin relief is a kind of stencil which has uniform round shapes. Hold it in place on your painting and apply paint over it, then lift it carefully to reveal the little round shapes. This technique works best with thicker acrylic paint rather than diluted ink. There are many other types of stencils available as well, and you can also make your own with special shaped hole punchers.

Stamps
There are numerous stamps with interesting patterns available, but use them sparingly. The one shown here is ideal for leaving imprints of distant trees, which can then be further manipulated with washes of colour.

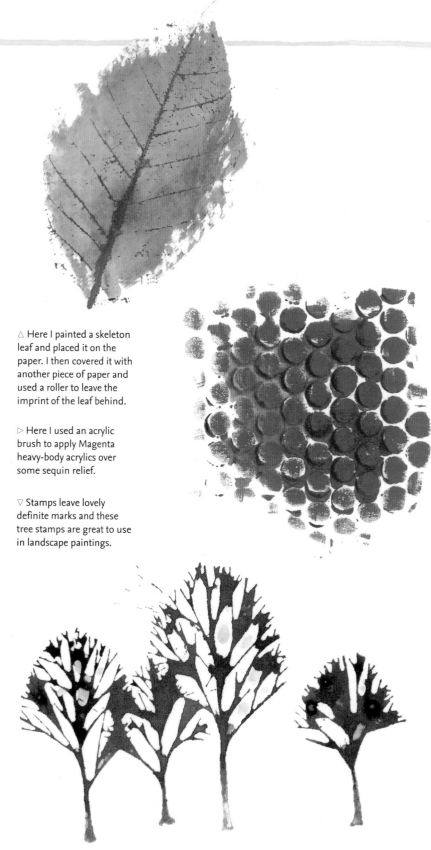

△ Here I painted a skeleton leaf and placed it on the paper. I then covered it with another piece of paper and used a roller to leave the imprint of the leaf behind.

▷ Here I used an acrylic brush to apply Magenta heavy-body acrylics over some sequin relief.

▽ Stamps leave lovely definite marks and these tree stamps are great to use in landscape paintings.

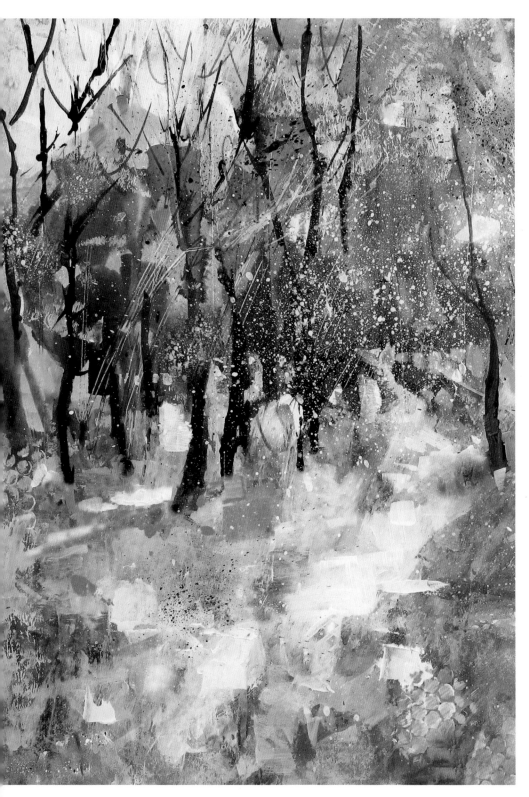

◁ **Snowstorm**
33 × 20 cm (13 × 8 in)

In this winter scene white
acrylic ink was spattered
specifically to represent the
snowflakes, but the sequin
relief marks were applied
just for added texture.
I also used sponges to add
some of the shadow areas
on the snow to make them
more random.

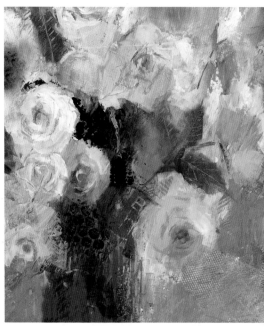

△ **Roses**
33 × 28 cm (13 × 11 in)

In this painting the imprints
of the skeleton leaves were
placed to represent the
actual foliage. Some bubble
wrap pressed on to the paint
was used to liven up the
dark area of colour and a
piece of netting was
included purely to add
texture in the lighter area.

OTHER VIEWPOINTS

It is refreshing to see the variety of approaches used by different artists painting in the same medium. The four paintings shown here exemplify the diverse and imaginative ways in which acrylic paint can be applied. The wide choice of supports, paints and techniques in acrylics offers an infinite number of possible combinations to explore.

▷ **Whitewater Lane**
LIZ SEWARD RELFE
40 × 60 cm (15¾ × 23½ in)

This sensitive piece of work by Liz puts the misconception about the garishness of acrylic colours to rest. A great variety of the most subtle and beautiful greens can be seen here, and the shafts of sunlight painted with light colours over dark add a touch of magic to this painting.

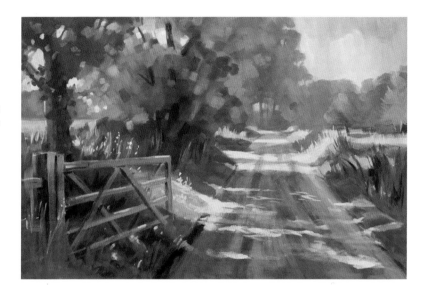

▷ **Venice, Late Summer**
MIKE BERNARD
76 × 102 cm (30 × 40 in)

Mike's highly imaginative paintings are often a combination of acrylic ink washes, over collage and a textured ground, with thicker paint applied by a roller. He often uses small pieces of mountboard to add vertical or horizontal lines for windows and buildings.

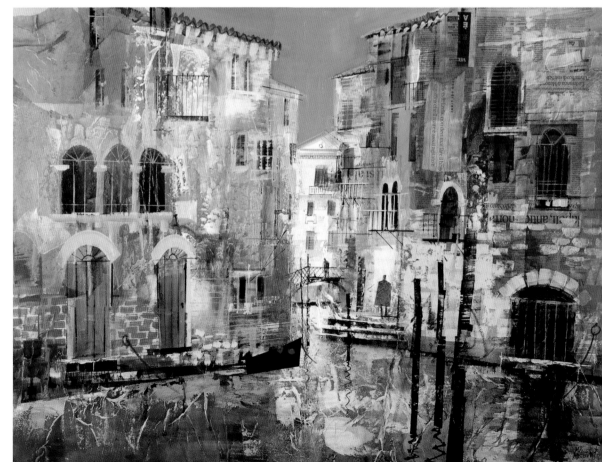

▷ **The Barn**
SUSAN KIRKMAN
50 × 70 cm (19¾ × 27½ in)

An underpainting of electric Brilliant Blue and Emerald Green provides a great backdrop for the superimposed areas of almost flat colour. Susan's bold use of colour and strong sense of compositional arrangement have created a truly dynamic image.

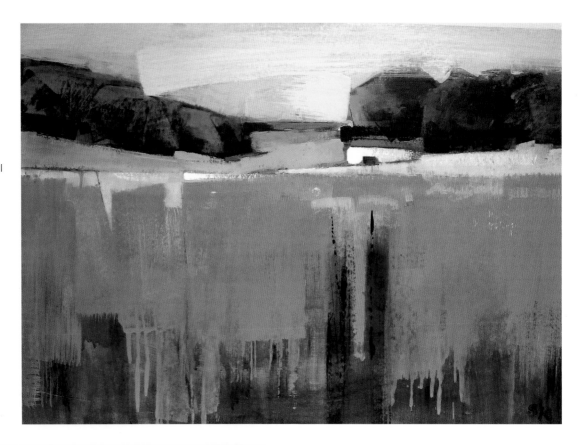

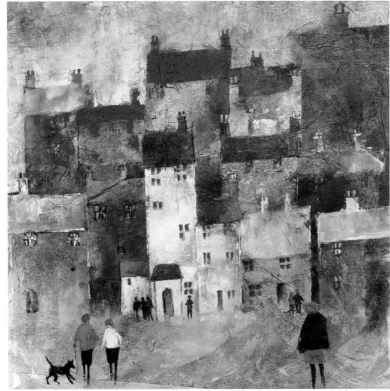

◁ **Townscape**
ROSEMARIE DE GOEDE
40 × 40 cm (15¾ × 15¾ in)

This painting is a great example of the vibrancy of acrylic colours. Rosemarie has great ability in balancing the bright and the quieter tones. Here she has set the scene with washes of acrylic colours over a textured ground, then overpainted a few areas with accents of bright colour.

Acrylics in mixed media

Painting in mixed media is by far the most liberating way of expressing your ideas. Each painting medium has its own unique qualities, inevitably with some negative as well as positive characteristics; but by combining media you can not only compensate for their shortcomings but also benefit from the individual colours and textures that each medium brings. As a result, this will help you to create more expressive and dynamic paintings.

Acrylic paint is a wonderful medium in its own right and it offers a wide range of techniques, but its receptive surface also makes it an ideal medium to use as a base for working in mixed media. When combined with other media, such as pastels and texture-making products, the artistic possibilities become endless – and great fun!

◁ The City Beyond
46 × 61 cm (18 × 24 in)

Acrylics with soft pastels

The soft and spongy surface of acrylic paint makes a very suitable base for soft pastels. By applying one or two layers of acrylic colour you can create enough tooth for soft pastels to grip – without this they would simply slide off a smooth surface. Applying a base of acrylics can also alleviate the problem of breathing in too much pastel dust.

A variety of supports can be made suitable for pastel painting if primed with a base coat of acrylics, such as mountboard, grey board, pulp board or even a smooth heavyweight card. Wet and dry artists' sandpaper can also be primed with acrylics for a strongly textured effect.

You can either apply an acrylic tint over the whole of your support or block in just the shapes and tonal values. By establishing these first, you can build the basic structure of the composition, then finish the painting with a layer or two of soft pastels. For an even more dynamic effect you can create texture either by leaving vigorous brush marks when you apply the acrylics or by scratching out interesting patterns into the wet paint. The hit-and-miss effect of pastel painted over a textured area makes for a very exciting surface.

I particularly love the combination of transparent washes of acrylic inks and pastel – the difference in the degree of light absorption gives an interesting and invigorating surface finish.

▷ **Street Vendors**
35.5 × 35.5 cm (14 × 14 in)

Here I used 425 gsm (200 lb) Not surface watercolour paper with newspaper and tissue collage added for textural effect. Initially I blocked in all the darks and mid tones with heavy-body acrylics, treating the subject merely as shapes. I then used soft pastels to add colour and tone, working on both the negative and positive shapes, and including detail and highlights to bring the subject to life.

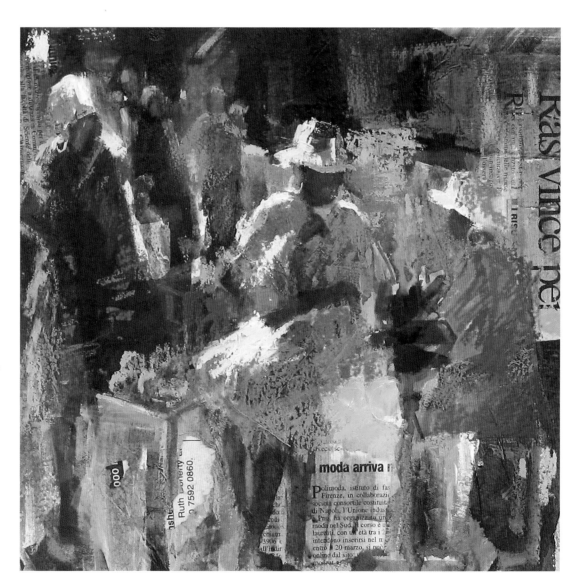

△ Oil pastels can be used underneath a wash to act as a resist (*right*), whereas soft pastels are usually applied over a wash (*left*).

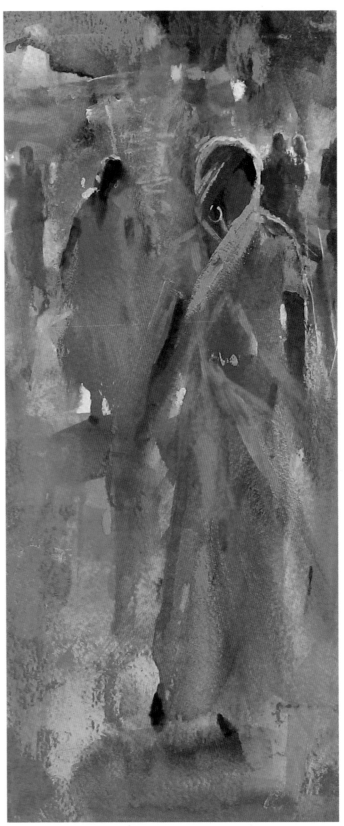

▷ **Indian Girls**
30 × 13 cm (12 × 5 in)

I used oil pastels to act as a resist in the initial stages of this painting, then added washes of acrylic ink to create an interesting coloured background. Thicker acrylics and oil pastels were used to define the figures and also to leave some pure abstract areas of colour.

Acrylics with oil pastels

Oil pastels are a relatively young medium: although the first versions were developed in the late 1920s, it was not until 1949 that Sennelier introduced their first range of high-quality oil pastels as requested by Henri Goetz and Pablo Picasso.

For best results, always use artist-quality oil pastels. These are made of pure pigment, inert oils, and mineral waxes to shape them into stick form. They are highly permanent and come in a range of fabulous colours. Many artists do not know a great deal about them and therefore tend to shy away from using this great medium on its own, but oil pastels combine very well with acrylics to produce beautiful passages in a mixed-media painting. They can be used in the early stages of a painting to resist acrylic inks or diluted tube colours, and at the later stages to enhance an area, add highlights or create an interesting accent of colour and texture.

Texture-making products

Texture has a great impact on the surface quality of a painting and on its overall design. Although it is possible to create implied or visual texture by clever use of brush marks, there is something more earthy and tangible about using a medium with a textured, tactile consistency.

A certain amount of texture can be achieved with heavy-body and superheavy-body acrylic paints, but the ever-expanding array of texture-making products that are available can enhance a painting in a way that is not possible with pure colour. Some of these products are mixed with the paints to create the desired effects and some can be applied as a ground prior to painting. Importantly, in all cases their chemical make-up is sympathetic to artists' colours and so they will not deteriorate over time and compromise the longevity of your artwork – an essential concern if you plan to sell your work.

I generally use products made by Golden, but most leading manufacturers have their own versions of some of these products so you can choose whichever suit you best.

Gel medium

This has a creamy consistency and is ideal for extending paint, adding texture and regulating translucency. Golden produces soft-body, regular, heavy- and extra heavy-body gels, so you can choose the right gel for the kind of texture you wish to apply. They are available in either a glossy finish, a lustrous soft sheen or a matt finish.

These gels broaden the range of texture effects that can be achieved considerably. Extra heavy-body gel, in particular, retains brush and palette knife marks, and is perfect for creating the texture of rocks, rough ground and other landscape details.

▽ Gel medium

Light modelling paste

Available from both Golden and Liquitex, this lightweight paste dries to an opaque, matt finish and it is great for creating both representational and abstract texture. Its consistency is designed to hold stiff peaks, resulting in a highly textured surface, and it blends well with acrylic colours. It is usually applied to the support with a palette knife. This versatile paste is good for portraying the textures of stone walls, brickwork, paths or tree bark.

◁ Light modelling paste

Clear tar gel

This is a colourless gel which has an extremely resinous and stringy consistency. It blends really well with soft-body acrylics or inks to make the required tint. Alternatively, you can use the gel to create a textured base prior to painting. Because it continuously flows from a palette knife or similar tool it can be dripped over surfaces, making it ideal for linear marks. It is useful for representing tangled piles of ropes, branches of trees or any stringy texture.

▷ Clear tar gel

Glass bead gel

This gel contains glass or plastic beads and it dries to a semi-gloss finish. It works quite well with washes of transparent acrylic colour to produce a reflective surface. The bubbly texture created by the beads can be used for numerous texture effects, especially for flower centres, and for beach scenes and seascapes. As with the other gels mentioned here, with imagination and some experimentation you will discover how glass bead gel can really jazz up your paintings.

◁ Glass bead gel

Pumice gel

Pumice gel, as its name suggests, creates a coarse and bumpy surface which dries to a hard film. It is available in different textures – fine, coarse and extra-coarse – and it can be mixed with other gels and mediums to increase its flexibility. It blends well with acrylic colours or it can be applied on its own with a palette knife to make a textured ground prior to painting. Pumice gel can be used for texture effects in both representational and abstract paintings, and is particularly good for portraying rough ground in landscapes or pebbles on the beach in seascapes.

▷ Pumice gel

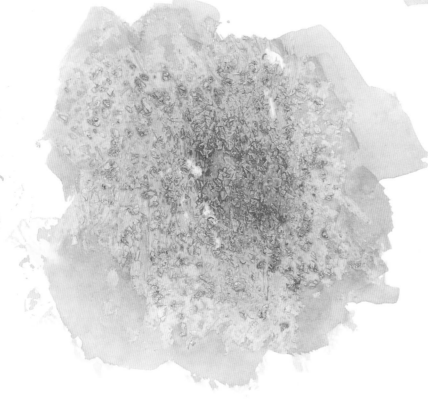

White opaque flakes gel

This product, made by Liquitex, is a heavy-body coarse gel, containing irregular-shaped white flakes. It can be used for creating rough grounds, to portray the texture of buildings and walls, and for numerous other abstract texture effects. Although it does blend with acrylic colours, it is best when covered with translucent layers of colour. Ideally, apply this gel with a palette knife to produce the desired texture and then leave it to dry completely before applying your washes of transparent colour.

◁ White opaque flakes gel

Studio tips

- To prevent damage to your brushes, always apply all gels with a palette knife.
- All gels must be completely dry prior to painting and this takes a while. Ideally, leave them to dry naturally, but if necessary you can use a hairdryer to speed up the process.

◁ **Searching for Crabs**
46 × 51 cm (18 × 20 in)

For this painting I randomly applied both gesso and Golden's Absorbent Ground to my watercolour paper to make a varied surface. Then I built up areas of texture with coarse pumice gel, white opaque flakes gel, glass bead gel and light modelling paste, before applying my washes of ink and acrylic paint.

Explore further

• Choose a subject such as a seascape which includes rocks, pebbles and sand in the foreground. Paint this using pure acrylics. Then try the same subject again, but this time incorporate texture-making products, such as heavy gel medium to sculpt the shape of the rocks, coarse pumice gel to suggest the pebbles, fine pumice gel for the smoother areas of the sandy beach, and tissue paper stuck down over the sea area. Compare the two versions of the painting in terms of their visual impact.

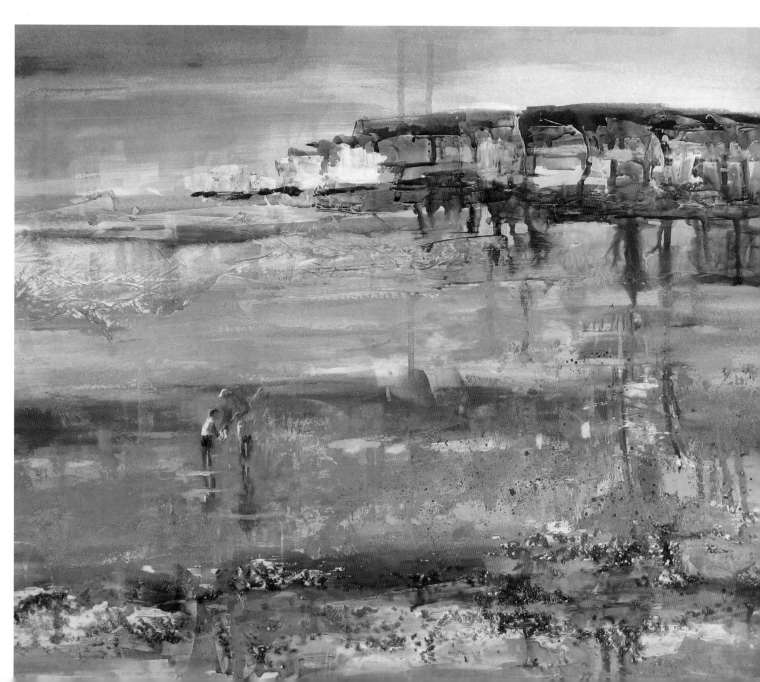

Painting with collage

Sticking flat pieces of hand-made paper, newsprint, cloth, tissue paper and similar items on to another flat surface, such as paper or board, is known as collage. Collage pieces can break up the surface very effectively and create beautifully random shapes, and when combined with acrylics can produce wonderful textures. The shapes can be manipulated into recognizable images or left as abstract forms.

Collage pieces can consist of anything that has textural or visual impact, or they may have more personal meaning and sentimental value. Remember, however, that less is generally more, so use enough material to add interest but do not overdo it.

Collage and mixed media

To stick down pieces of collage you can use either PVA glue or any of the acrylic mediums; make sure that everything is stuck down firmly. A painting with collage can be built up with layers of ink, thicker acrylics, oil and soft pastels, or other compatible media. I tend to keep to water-based media when working in this way and acrylics seem to be absolutely ideal for the job. If you decide to include pieces of coloured tissue in your collage, to prevent them fading always reinforce the colour with washes of ink.

This method suits artists who wish to work in an experimental way. Many find that incorporating collage into their work takes it towards an abstract style and results in more contemporary images. I find the combination of collage and washes of acrylic ink a really magical and exciting approach to painting. If you try working with collage, keep an open mind and let the unpredictable nature of this technique guide you. In other words, learn to relax and go with the flow!

▽ **Busker in Venice**
46 × 56 cm (18 × 22 in)

In this painting I used collage in the form of pieces of text to suggest the advertising posters on the wall. Washes of ink established the colour scheme and the painting was finished with soft and oil pastels and heavy-body acrylics.

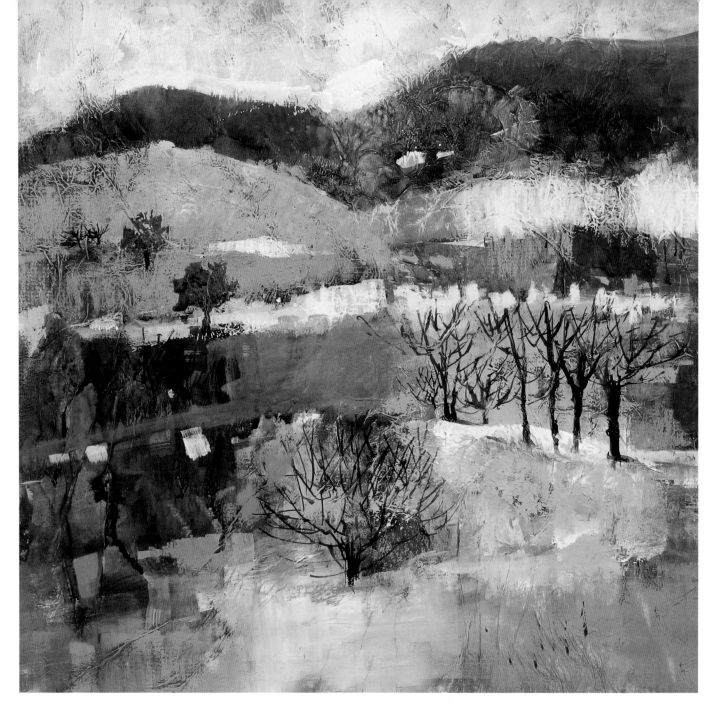

△ **Winter Landscape**
42 × 40.5 cm (16½ × 16 in)

To create this scene I first covered an unwanted flower painting with glue. I crumpled a piece of acid-free tissue paper, then smoothed it out over the whole glued area. The tissue retained the crease marks and made a lovely textured surface. I dried this before painting the scene over the top.

Studio tips

- Always keep a few old brushes specifically for pasting collage pieces.
- If you add collage at later stages of your painting, make sure to blend it in.
- Do not use any collage items that may subsequently perish and compromise the quality of your work.

Some subjects, such as this old Venetian building with peeling plaster on its walls, lend themselves perfectly to being painted on a more textured surface. In this demonstration the pieces of collage interact with the washes of acrylic inks and colours to suggest the decaying plaster very effectively.

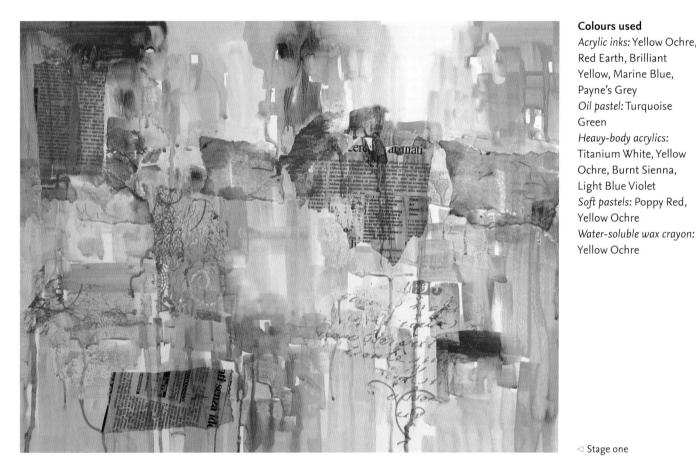

◁ Stage one

Colours used
Acrylic inks: Yellow Ochre, Red Earth, Brilliant Yellow, Marine Blue, Payne's Grey
Oil pastel: Turquoise Green
Heavy-body acrylics: Titanium White, Yellow Ochre, Burnt Sienna, Light Blue Violet
Soft pastels: Poppy Red, Yellow Ochre
Water-soluble wax crayon: Yellow Ochre

Stage one
First I stuck down torn pieces of hand-made paper, newsprint and tissue paper on to a piece of mountboard, using PVA glue and an old brush, then dried the surface thoroughly with a hairdryer. I added washes of Yellow Ochre, Red Earth and Brilliant Yellow acrylic inks, using a soft 2.5 cm (1 in) wash brush. The colour wash was intentionally applied unevenly so that subsequent applications of paint would resemble the decaying plaster more effectively. Once again I dried the surface completely.

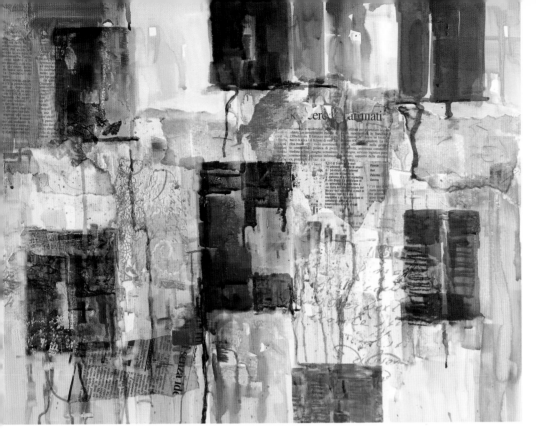

Stage two

I applied a few short horizontal lines of Turquoise Green oil pastel to indicate the slats of the shutters for three of the windows. Then I established the position of the windows by applying a wash of Marine Blue acrylic ink, adding a wash of Payne's Grey acrylic ink for the darker areas. The oil pastel resists the ink and shows through.

◁ Stage two

Stage three

I used Light Blue Violet heavy-body acrylic to paint the clothes on the washing line. Then with tints of Burnt Sienna and Yellow Ochre heavy-body acrylics I suggested the decaying plaster on the wall around the windows, using the dry-brush technique. I used Poppy Red soft pastel to paint the geranium flowers in the window box of the central window, and splattered some ink to add further interest to the patterns on the wall. I added more lines to indicate the shutters, using both Turquoise Green oil pastel and Payne's Grey acrylic ink.

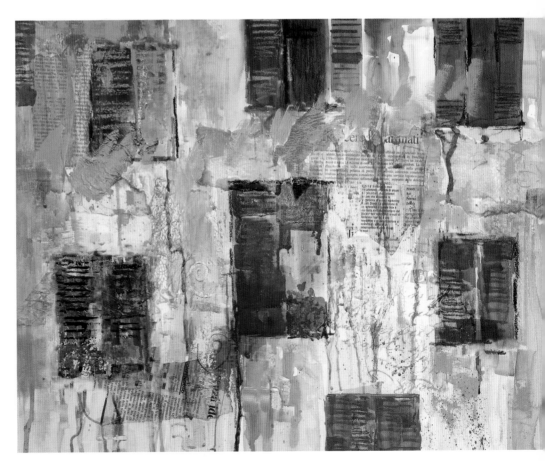

▷ Stage three

DEMONSTRATION

Stage four

I finished painting the windows using the Turquoise Green oil pastel. Then I applied more washes of Red Earth and Yellow Ochre acrylic ink to the walls and put in the finishing touches with Yellow Ochre soft pastel and water-soluble wax crayon. I added a smaller washing line in the bottom left-hand corner to create balance and applied white highlights to all the clothes using Titanium White heavy-body acrylic. Finally to complete the picture I painted the balcony railings and the main washing line with Payne's Grey acrylic ink.

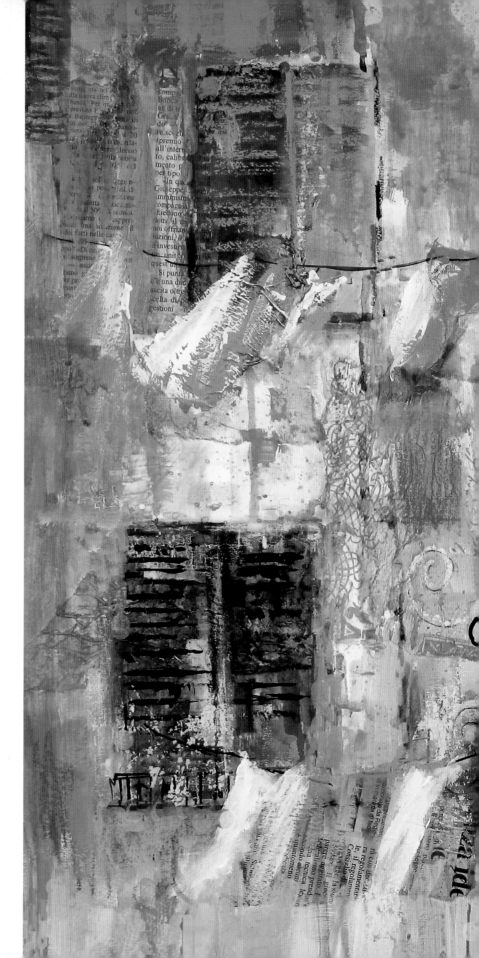

▷ Venice Windows
40.5 × 51 cm (16 × 20 in)

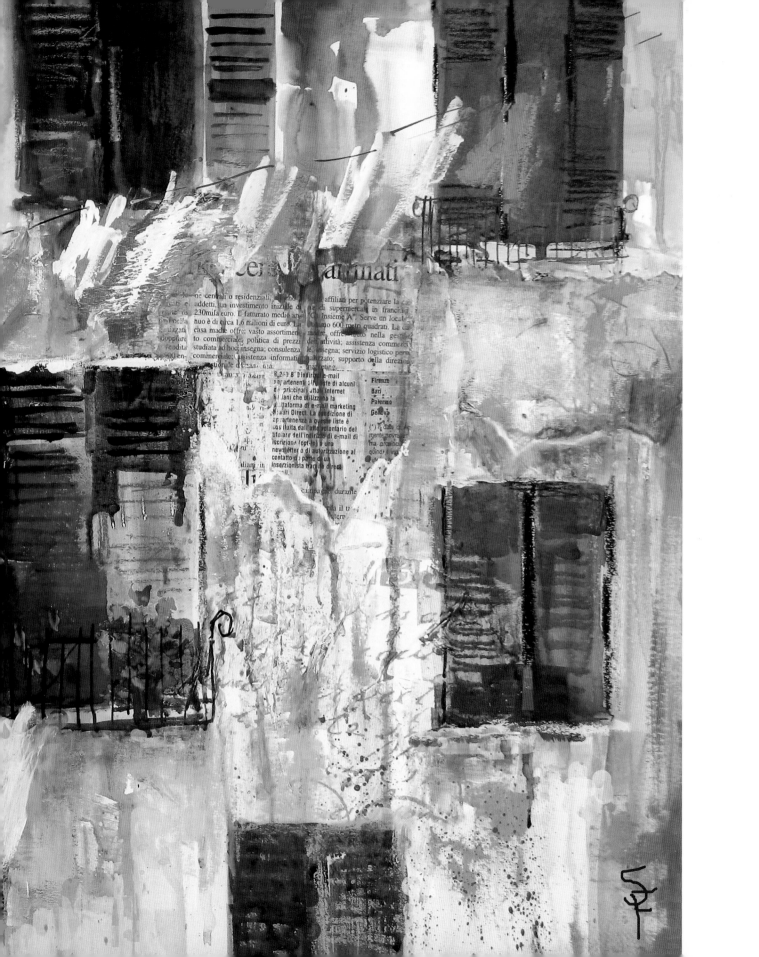

OTHER VIEWPOINTS

By combining different media, working with other implements, and using collage and pattern-making materials you can enhance a painting in a way that is almost impossible with pure colour and more conventional techniques. These two pages showcase the work of three leading artists who use this approach to perfection.

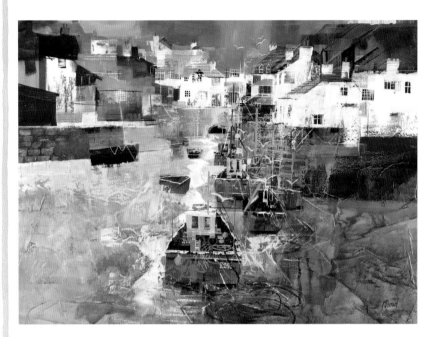

◁ **Red Fishing Boats, Polperro**
MIKE BERNARD
76 × 102 cm (30 × 40 in)

This painting was done over a collaged surface made of tissue and printed text. Mike's highly imaginative paint application, pattern-making materials and use of alternative implements, such as a roller to apply colour, create heavenly abstracted passages in this unique portrayal of Polperro.

▷ **Yorkshire Sheep**
ANN BLOCKLEY
37 × 40.5 cm (14½ × 16 in)

In this wonderfully tactile painting Ann has incorporated pieces of wool stuck down with PVA glue to portray the texture of the sheep. She has then reinforced the texture with gesso prior to painting, creating maximum visual impact in an otherwise ordinary subject.

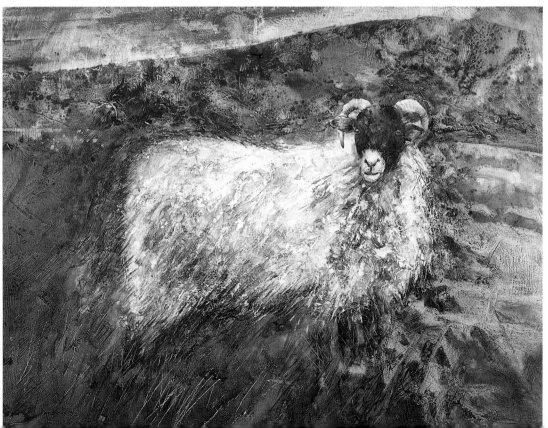

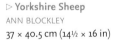

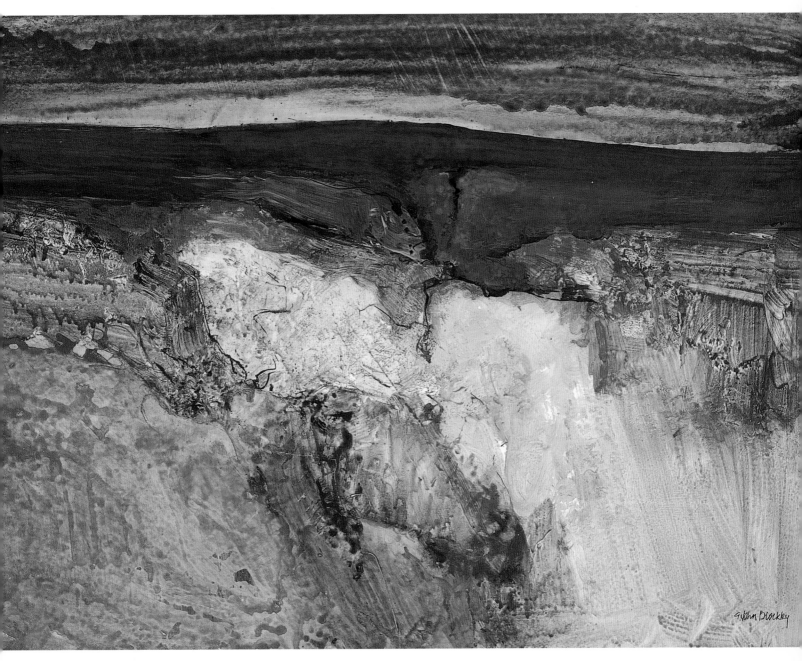

△ **Swaledale, Yorkshire**
JOHN BLOCKLEY
40.5 × 51 cm (16 × 20 in)

John was without doubt one
of the most inspirational
artists of his generation and
his work never fails to excite.
In this superb abstract
landscape the textured
passages are beautifully
counterbalanced by the
quieter areas.

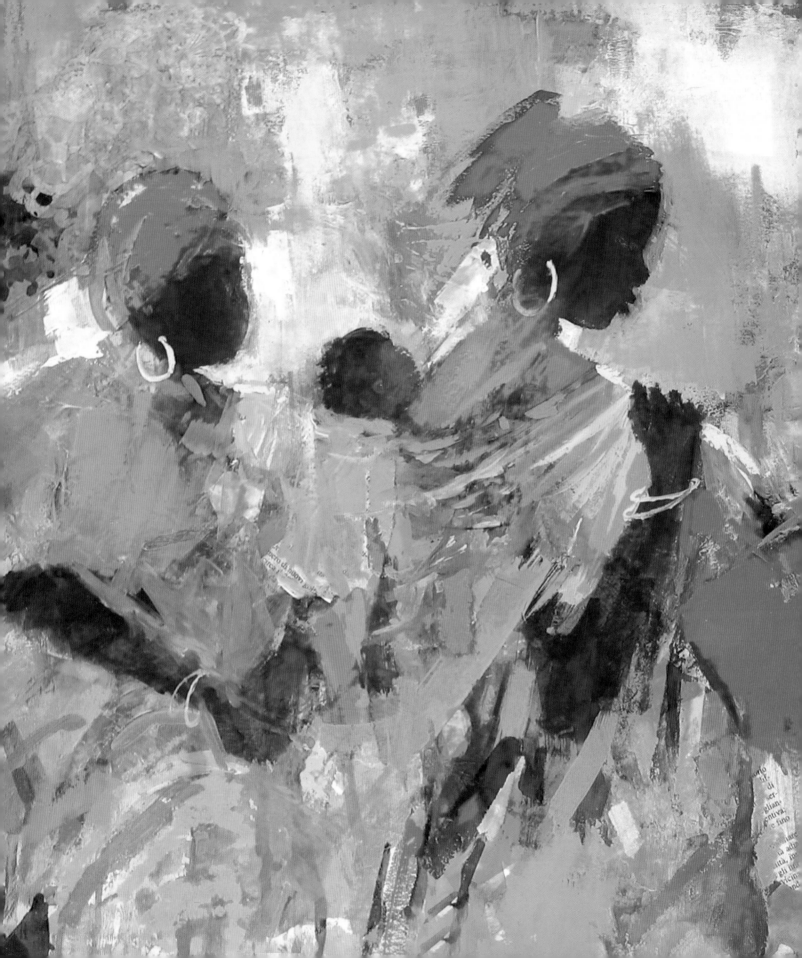

The visual language

Communication through pictorial imagery goes way back beyond the existence of written words and language. Artists communicate with their viewers through a visual language; for them, the elements and principles of design are their vocabulary, and the painting medium their vehicle for expression.

The visual language is universal: it breaks down racial, cultural and language barriers to enable artists to communicate to a much wider audience. It is a powerful language, through which the artist's vision can be shared with the viewer, sometimes even conveying significant messages.

This chapter looks at ways in which you can begin to develop your own artistic expression.

◁ Helping Hand
40.5 × 51 cm (16 × 20 in)

Finding your voice

A frequent concern amongst some of my students who have reached a high standard of technical ability is that they have not yet found a common thread within their paintings. The work of most successful artists is recognized immediately by a dominant aspect evident in it. This can be their choice of colour and tone, their subject matter, or the distinct quality and style of their brush marks – whatever it is that makes that artist unique and distinguishes their work from that of another painter. It is their visual voice and it reflects their identity as a painter.

Finding your own artistic voice is a process that comes about naturally through regular practice; gradually external influences will become less marked and relied upon, and your personal signature will take over.

Your personality, attitude, likes and dislikes, opinions and social background all play a part in your development as an artist. To start with, most artists experiment with a variety of different media, subjects and techniques before settling on what they find best conveys what they are trying to put across to the viewer. The lucky few arrive at this juncture quite early on, but for most artists it becomes an ongoing and lifelong process.

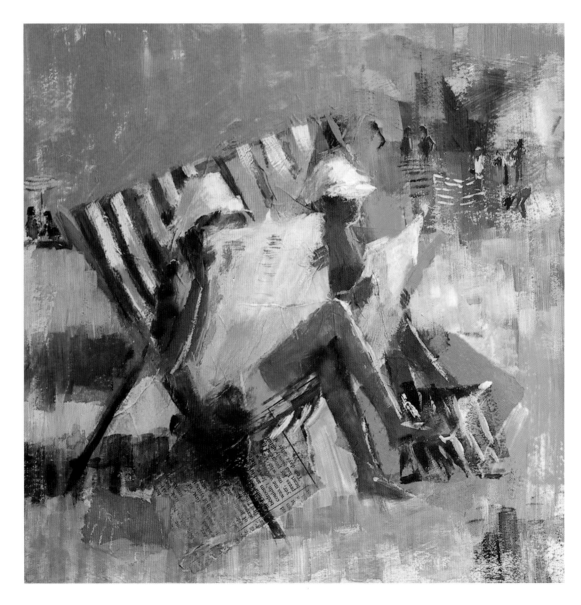

▷ **Sunday Papers**
30 × 30 cm (12 × 12 in)

This painting was built up using collage, inks and heavy-body acrylics, and it is a typical example of the way in which I interpret my source material.

△ **Medley**
28 × 40.5 cm (11 × 16 in)

When I start a painting
I always have lots of ideas
floating around in my mind
– rather like the medley of
collage pieces here.
Although I try to visualize
the end result, I keep an
open mind as things do not
always go to plan and the
painting may take me in a
different direction.

The creative thinking process

In painting, although technical ability is vitally
important, it is just a means to an end. It is the
creative thinking process that is the real driving
force behind the creation of an artwork. This is the
element that separates the artist from the copyist
and brings out the individual within. It is the ability
to see potential and interpret what you see in a
unique and imaginative way.

This is the most challenging part of being an
artist. It is something that cannot be taught, but
with dedication and commitment it can be nurtured
and encouraged. It is about brainstorming ideas,
combining different ways of looking at a subject,
and then coming up with new and unique

interpretations. Creative thinking cannot be forced
or actively pursued; ideas present themselves when
you least expect them, and it is crucial to be aware of
this and to be ready to take advantage of them. To be
able to find your unique voice as an artist, you must
ensure that creative thinking becomes an ongoing
process and a major part of your life.

Studio tips

• Write down ideas for paintings as and when you think
 of them, whether it is a subject or colour selections or
 any other aspect of making a picture.

Creating semi-abstract passages

Much of my work starts with a particular subject in mind, mostly one where I can manipulate the effect of light and colour to the full. I tend to create a chaotic surface initially by blocking in the shapes in dark and mid-tone values or by adding a coloured ground. In the process of pulling the painting together, through painting a series of positive and negative shapes, some pure or semi-abstract shapes are inevitably formed and these are left to support the main point of interest. This gives viewers something to play with and hopefully enables them to engage with the painting for longer.

Paintings which include abstracted passages are generally more enigmatic and much more stimulating for the viewer. For example, in a busy street scene where people are the focus of attention, it is often better to simplify the buildings in the background by merely suggesting them with a series of abstract marks. In the case of flower paintings, whereas a purely botanical rendition of flowers depends on the depiction of every minute detail, when flowers are painted in an impressionist and more painterly style the foliage and background tend to work much better if they are totally or partially abstracted. This can also help to highlight the shape of the flower heads.

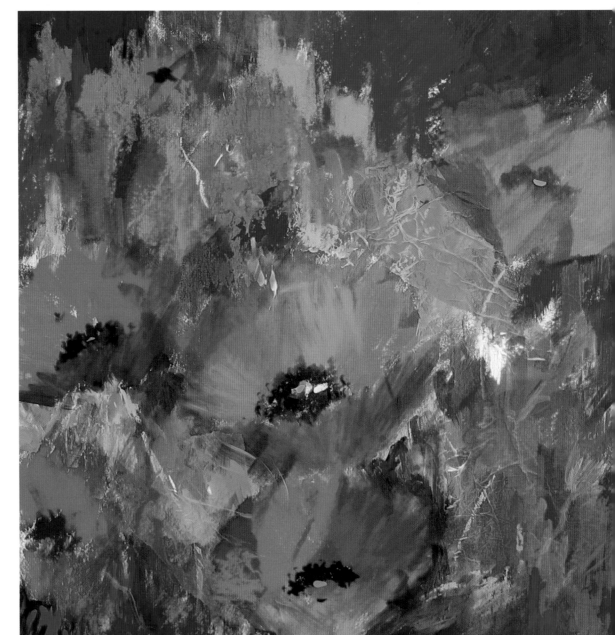

▷ **Red Poppies**
30 × 30 cm (12 × 12 in)

Although the background in this painting has been abstracted the viewer still reads certain areas within it as foliage.

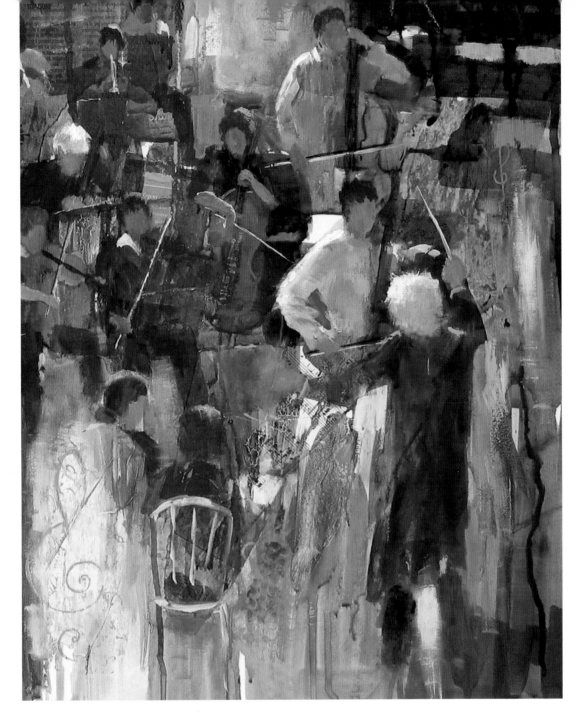

In this painting many of the lines are blurred and merge into negative shapes, leaving quite undefined passages that are just as important as the well-defined areas in creating a successful image.

Lost and found edges

An edge is created where two shapes or areas meet. In reality, every single object is distinguished from its neighbours by changes of colour and tone. Beginners in painting tend to draw every shape carefully, separating them by adding outlines around each one. This is especially true where figures are included in a painting. However, too much clarity and precision when portraying edges make the painting too rigid and lifeless. A clever and more experienced artist will engage the viewer with the painting by letting some of the edges merge into the background. This principle of lost and found edges is one of the best ways to entice the viewer to use their imagination and fill in the visual gaps where the edges are not clearly defined. This interaction makes the painting more dynamic and appealing than one which demands no involvement from the viewer.

Creative mark making

The artist's brush marks and the textural quality of the surface are key elements in the overall success of a painting. Even if the subject matter is simplified to include just the bare minimum of detail, it can still manage to put across a very powerful message simply through the use of visually enticing marks made by the artist. On occasions I have fallen in love with a painting purely on the basis of the magical quality of the mark making, with hardly any interest in the subject matter itself.

The unique characteristics of acrylic paints open up tremendous possibilities for combining both translucent and opaque techniques to achieve highly distinctive and dynamic images. The compatibility of acrylics with other media and texture-making products also gives you ample opportunity for creative mark making. With regular practice of these exciting techniques you will eventually find your personal way of applying acrylics. This creativity is what separates the painter from the photographer, and it comes with much hard work and experimentation on the artist's part.

▽ **Italian Buildings**
40.5 × 51 cm (16 × 20 in)

This painting is all about mark making and the surface finish. It incorporates collage pieces, and a roller and stencils were used to re-create the feel of the old Italian buildings.

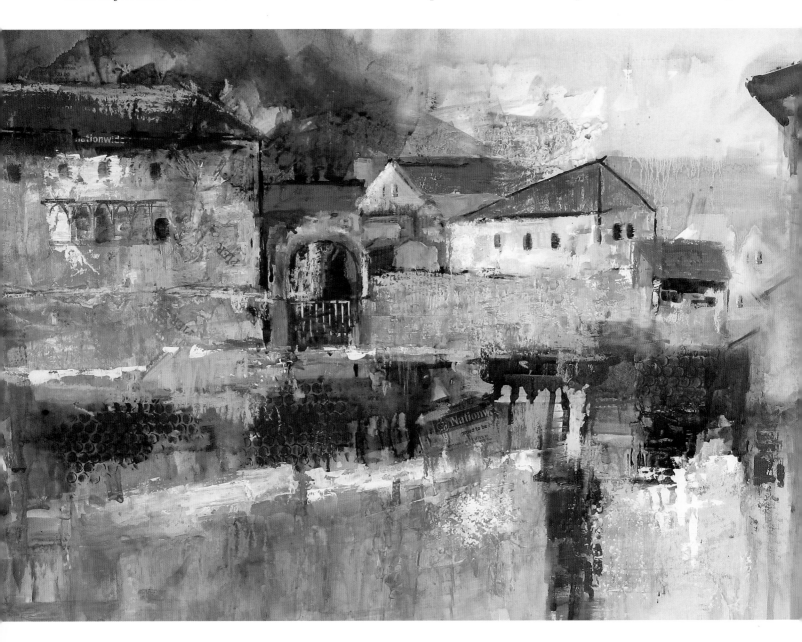

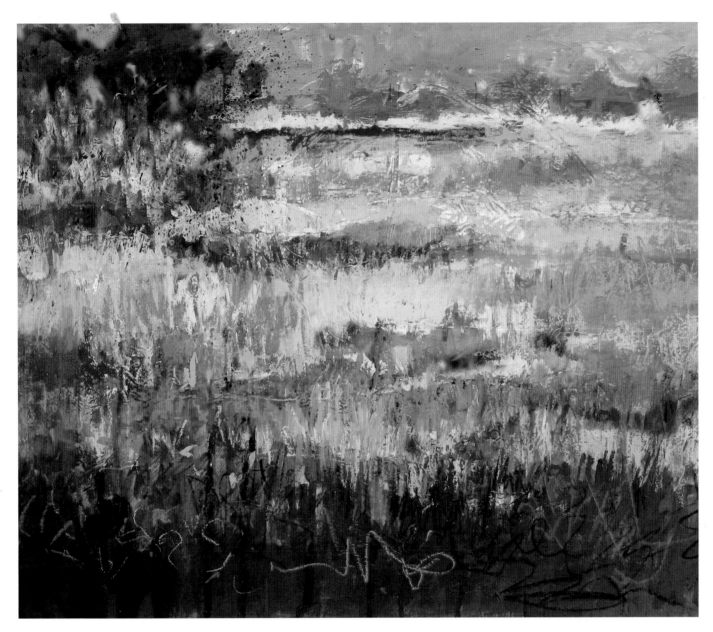

△ **Hampshire Fields**
35.5 × 40.5 cm (14 × 16 in)

I pass these fields every day on the way to my studio. I love their ever-changing colours and textures. I used the sgrafitto technique to suggest the coarseness of the field by scratching out a variety of marks.

Explore further

• Choose a subject with potential for experimenting with a variety of mark-making techniques. Paint this once and create visual texture by using your brush merely to suggest or imply it. Then paint the same subject again, this time making tactile texture through various texture and mark-making techniques – for example, using paper collage, sgrafitto, or applying paint with a roller. Compare the two versions and decide which has the most visual impact.

OTHER VIEWPOINTS

Technical ability can be achieved through regular practice. However, to be established as an artist you must nurture and encourage your creative thinking process and strive to find your unique visual voice. The paintings featured here are immediately recognizable as the artists' work through their original use of artistic elements.

▷ **Wittenham Clumps**
SUSAN KIRKMAN
38 × 50 cm (15 × 19¾ in)

Susan's work is characterized by her wonderful sense of colour, abstraction of the subject matter, strong and self-assured linear marks, and her brilliant way of superimposing areas of flat colour. For me this particular painting is reminiscent of the work of my two favourite early 20th-century painters, Paul Nash and Keith Vaughan.

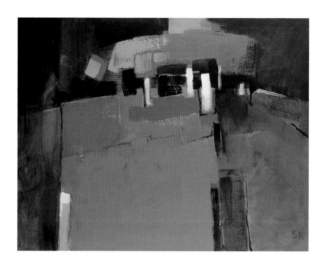

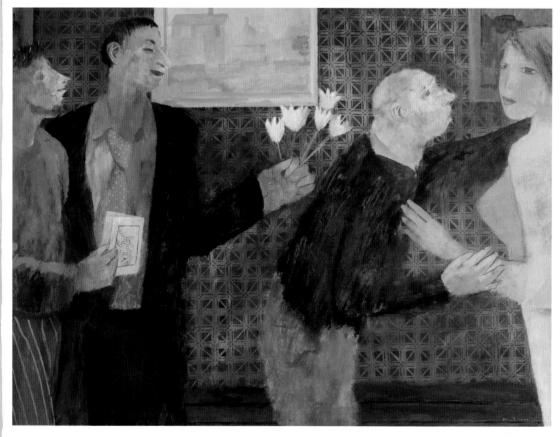

◁ **Housewarming**
RICHARD SORRELL
91 × 122 cm (36 × 48 in)

Richard has the magical ability to turn everyday scenes overlooked by many of us into superbly imaginative paintings. The narrative in his highly original paintings keeps the viewer engaged with them. They always make me smile, as I feel I know these people and have been to these places.

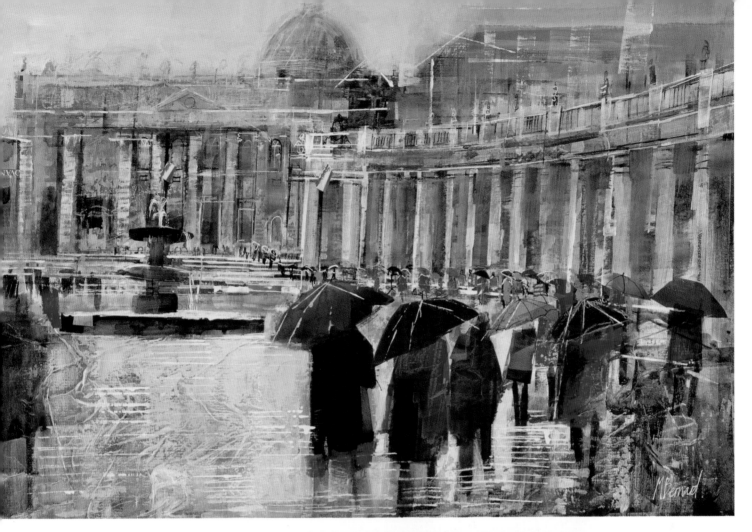

△ **Rain Showers, St Peter's, Rome**
MIKE BERNARD
42 × 61 cm (16½ × 24 in)

Mike's masterful use of mixed media combines narrative with areas of pure and semi-abstract passages. Looking at this painting is like a treasure hunt as you discover yet another intriguing shape, accent of colour, or interesting piece of collage.

◁ **Demolition**
JOHN BLOCKLEY
46 × 46 cm (18 × 18 in)

This painting is a celebration of texture, tone and colour. The combination of abstract areas with recognizable elements intrigues the viewer – there is something new to discover every time you look at this image.

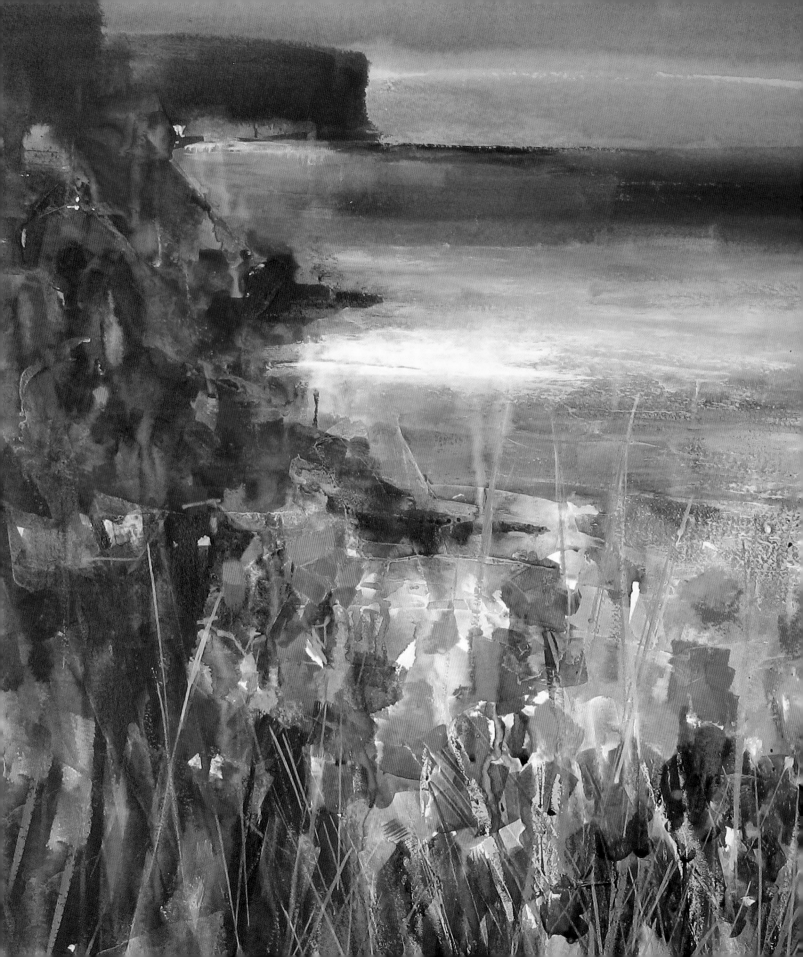

Gathering ideas

In general, dedicated artists are hypersensitive to their surroundings, forever on the lookout for a subject to develop and interpret in their chosen medium. They have a different way of seeing everything and are always receptive to new ideas. A huge part of the fun of a creative pursuit such as painting is the gathering and processing of ideas – that heart-racing moment when you are faced with a potential subject is quite addictive. It is important to take advantage of these moments, making a record with a quick sketch and taking a few notes, in order to create a library of reference material for future paintings.

In this chapter we look at ways to cultivate the imagination, improve observational skills and increase sources of inspiration.

◁ Cornish Cliff Tops
51 × 61 cm (20 × 24 in)

Sources of inspiration

Inspiration is the motivating factor behind the act of painting. It is that all-important little spark that ignites the fire of creativity. Without it painting can become a chore and the resulting work will reflect this by being mechanical and lifeless.

Sources of inspiration are as varied as the number of artists. What can be hugely exciting and inspiring for one artist can be as dull as dishwater for another. While some artists are focused on particular subjects, for others it may be specific aspects of a subject that are more inspiring, such as the potential for creating a certain mood and atmosphere. They may, for instance, paint flowers simply for the sheer pleasure of playing with colour. It is important, too, not to confuse inspiration with the actual subject matter, which in my opinion is the by-product. An artist who has no interest in painting trees but is highly influenced and inspired by the effect of light may attempt a landscape subject for the pure joy of capturing the light through the trees.

The common ground, however, is the influence that artists have on one another. Throughout history groups of artists have come along with new, innovative ideas and have influenced and paved the way for subsequent artists. The Impressionists are a great example of this: they brought light, colour and texture into their paintings in a way that had never been seen before, changing rigid and archaic ideas, and inspiring many artists who followed in their footsteps.

To grow and evolve as an artist it is vitally important to recognize your sources of inspiration and what makes you tick artistically, in order to focus and have an ongoing flow of creative energy.

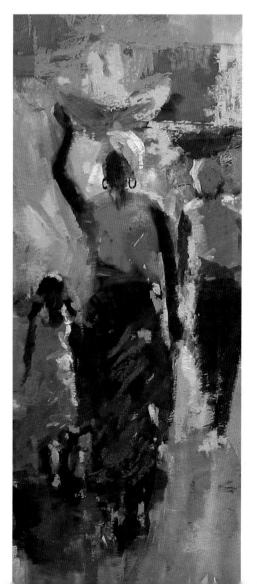

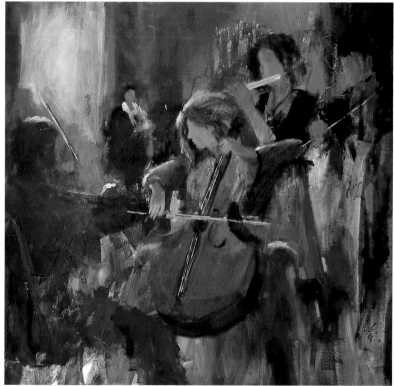

◁ **Going to Market**
40.5 × 16.5 cm (16 × 6½ in)

I find the colours and people of the Caribbean and Africa so inspiring. I can indulge my passion for colour, light and movement with these subjects.

△ **The Cello Player**
35.5 × 35.5 cm (14 × 14 in)

Musicians are another great source of inspiration for me. I find the compositions they create irresistible and the combinations are infinite.

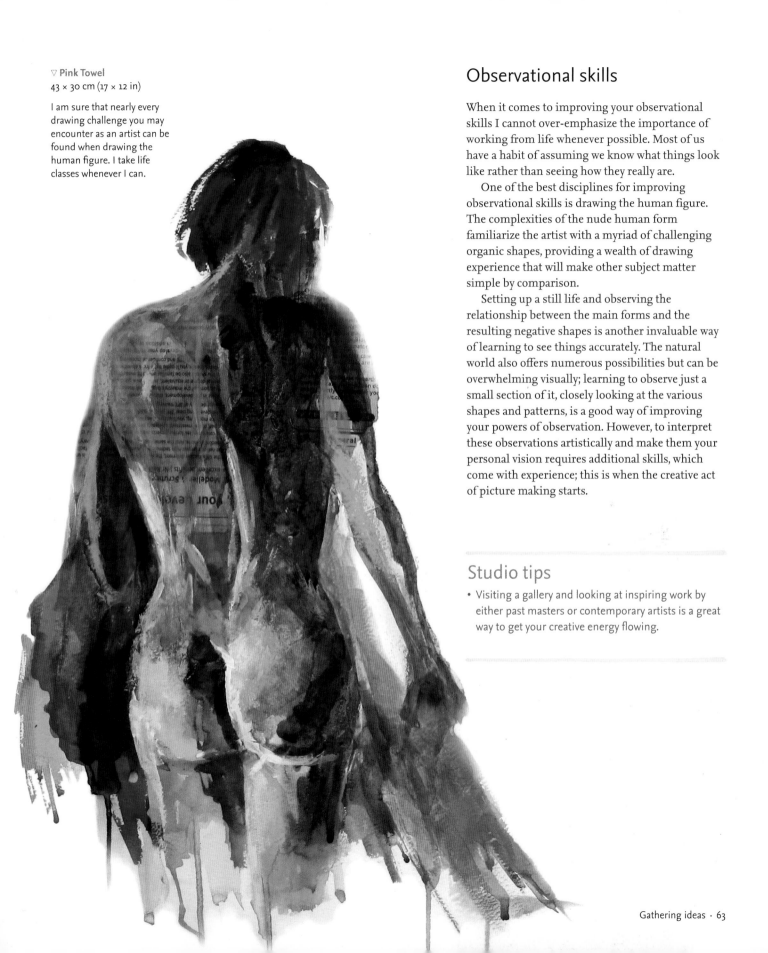

▽ Pink Towel
43 × 30 cm (17 × 12 in)

I am sure that nearly every drawing challenge you may encounter as an artist can be found when drawing the human figure. I take life classes whenever I can.

Observational skills

When it comes to improving your observational skills I cannot over-emphasize the importance of working from life whenever possible. Most of us have a habit of assuming we know what things look like rather than seeing how they really are.

One of the best disciplines for improving observational skills is drawing the human figure. The complexities of the nude human form familiarize the artist with a myriad of challenging organic shapes, providing a wealth of drawing experience that will make other subject matter simple by comparison.

Setting up a still life and observing the relationship between the main forms and the resulting negative shapes is another invaluable way of learning to see things accurately. The natural world also offers numerous possibilities but can be overwhelming visually; learning to observe just a small section of it, closely looking at the various shapes and patterns, is a good way of improving your powers of observation. However, to interpret these observations artistically and make them your personal vision requires additional skills, which come with experience; this is when the creative act of picture making starts.

Studio tips

• Visiting a gallery and looking at inspiring work by either past masters or contemporary artists is a great way to get your creative energy flowing.

Sketching

A sketchbook is a visual diary of your observations. Sketches are intimate and spontaneous, often possessing a liveliness that may be lacking in the resulting painting. Some artists' sketchbooks are filled with beautiful drawings, while others, such as mine, are a jumble of information and sketches drawn either on one of the pages or on the back of a cheque book or a napkin and then stuck to the pages with tape! I rarely share my sketchbooks with others; the contents are often too chaotic to make sense to anyone but me. I record anything and everything that sparks an idea, from swatches of colour to descriptions of something or someone that I found interesting and inspiring.

Use your sketches to record just what really interests you about a particular subject rather than everything that you see. Whereas a photograph can contain too much information and be rather disappointing, sometimes failing to record the mood and freshness of the actual scene, a sketch can capture the essence of a subject much more effectively. By careful observation as you sketch you will get to know your subject intimately and you will find that this often leads to a painting that really evokes a sense of place and as a result touches the viewer at a deeper level.

▷ **Jamaican Hut and Washing Line**
20 × 25.5 cm (8 × 10 in)

A little tonal pen and ink sketch such as this takes a few minutes and provides a lovely subject to paint on a rainy day.

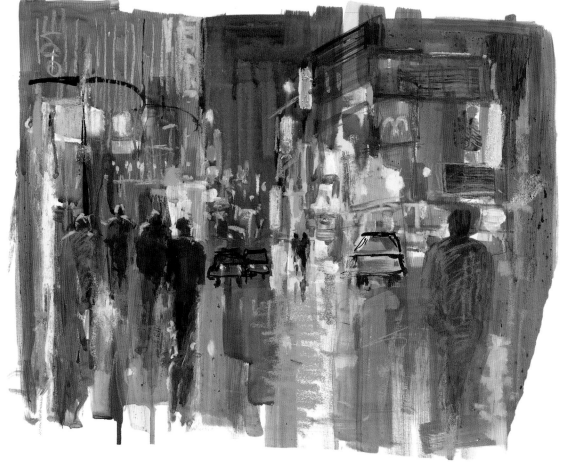

▷ **City Lights**
30 × 40.5 cm (12 × 16 in)

This is a typical colour sketch of mine, inspired by a trip to London and composed from a couple of photographs. I used washes of acrylic inks to capture the bright colours of the scene.

Painting from photographs

Some artists regard using photographic references as cheating, but in fact painting and photography have had a close connection since the invention of the camera: a number of past masters used the early versions of this amazing device to record their subject matter. Many contemporary painters now use photographs alongside their sketches and notes, and while working from life and *en plein air*.

In order to paint successfully from photographs it is important to have experience of painting from life and observing subjects in the three-dimensional world. This will help you to create a painting that is not simply a pale imitation of the photograph but your own artistic interpretation of the scene. It is also important to recognize the shortcomings and limitations of photographs. For example, you must learn to leave out unwanted information and to gauge the tonal values correctly. The composition of photographic references is rarely satisfactory and will often need to be edited or cropped before the photographs can be effectively used. I frequently come across students who inadvertently change the format of the photograph from portrait to landscape for their painting and end up with a failed composition as a result.

Using a digital camera

My subjects are often set in the hustle and bustle of busy streets and markets, and capturing these transient moments with a camera is a great help. I have carried a digital camera with me since they were first available. Indeed, the invention of digital photography has transformed many artists' lives. The ability to use the camera's viewfinder to compose a scene can be a great advantage, as is the opportunity to take many shots and then delete unwanted ones. Tweaking and manipulating images in computer programmes such as Photoshop and working out the best composition by cropping and so on are also all great facilities. Like the other conveniences of modern life it is a good idea to take advantage of them if you can.

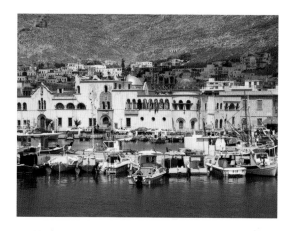

◁ The waterfront at Kalymnos.

△ **Kalymnos**
46 × 56 cm (18 × 22 in)

My aim here was to capture the inspiring sight of these beautiful buildings. I used collage to create a textured surface and then manipulated the random shapes to form the buildings. I even used some gold leaf on the central dome.

Finding your subject matter

Once you have established the sources of your inspiration, you can focus on finding your subject. The choice of subject matter is highly important. It has to feel right so that it inspires you to put a great deal of artistic energy into it and do it justice.

Apart from the sheer enjoyment of painting and the personal gratification that is gained, another significant reason why artists paint is to evoke a response from their viewers. You cannot please everyone, but what matters most is how you interpret a subject. This becomes more obvious in successful non-objective, abstract paintings where the literal subject matter has been obliterated. The artist may have replaced the complexities of a landscape, say, with their own complex use of pattern, shape and colour, yet they are still able to convey their genuine excitement to the observer and get a positive reaction. On the opposite side of the coin, many artists find commissioned paintings the least satisfying to paint as they feel detached from the subject and consequently cannot emotionally engage with the painting.

To find the right source material and produce a dynamic image, therefore, you must choose a subject that touches you at many levels and, above all, rings true to your artistic self. Borrowed ideas that do not come from within will lack authenticity and will come across as false. Once again, the versatility of acrylics as a medium offers the artist ample opportunity to tackle any subject in a more creative and dynamic way than any other medium.

△ **Jazz and Saasha**
30 × 25.5 cm (12 × 10 in)

My children feature in many of my paintings and have been a great source of inspiration to me.

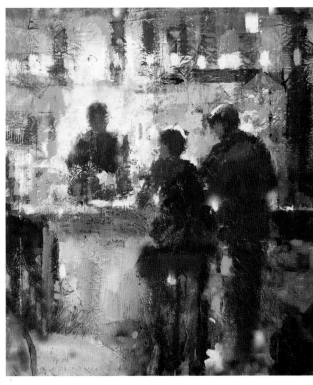

▷ **The Wine Bar**
33 × 31 cm (13 × 12¼ in)

I find the dim light and rich colours of the interiors of wine bars and restaurants fascinating. I can fully indulge in creating the dramatic contrast of dark tones against the artificial light source.

Studio tips

- To kick-start a dormant or stale imagination, try watching an inspiring artist at work, looking through your art books and magazines, or taking a painting course with a fresh approach.
- Get out of your comfort zone and try something unusual, such as painting a subject you have never painted before or using a new technique or medium.

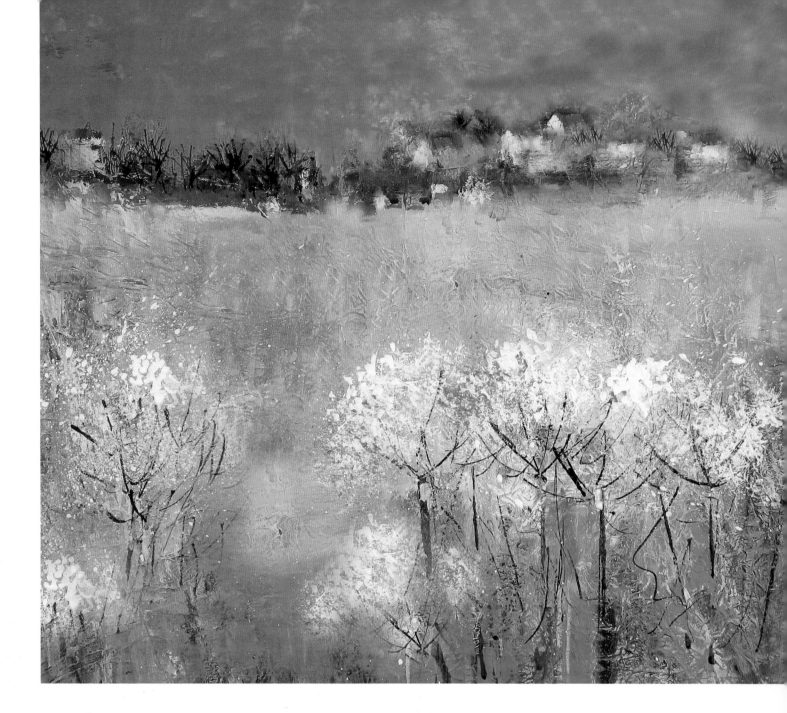

On your doorstep

In the quest for finding that elusive inspiring subject it is easy to overlook the magic of the ordinary and mundane objects that surround us in day-to-day life. Indeed, many artists spend a lifetime exploring these seemingly commonplace yet intimate domestic subjects, not only finding much comfort in their familiarity but also huge scope for discovering their potential in paintings. Every room in the house offers numerous possibilities. Many times you can walk in on a found still life but fail to recognize it as a suitable subject for a painting, instead taking pains to arrange objects artificially in order to paint them.

A wealth of subject matter can also be found in gardens, as well as an abundance of possible landscape or townscape subjects right on your doorstep. You do not have to go very far to find one – no matter how ordinary a subject may seem, with a bit of imagination, creative techniques and sympathetic use of the principles and elements of design it could turn into a beautiful painting.

△ **Hampshire Fields with Giant Hogweed**
37 × 38 cm (14½ × 15 in)

In the beautiful county of Hampshire I do not need to go very far to find inspiring subject matter. These golden fields are quite close to where I live.

Landscapes

In this particular genre of painting the viewer is invited to share the artist's unique vision of a corner of this vast and beautiful planet of ours. Paintings of landscapes rendered in a photographic style merely highlight the impossible job of trying to compete with nature and are rarely exciting or satisfying. After all, the camera is the best tool to achieve this kind of imagery. Your challenging task as an artist is to interpret what you see in nature in your own unique visual language. In reality, with all the different elements of the natural world vying for the artist's attention, this may seem rather daunting at first. With practice and experience, however, you will learn how to select an area of interest and not be totally overwhelmed by the great outdoors. Simplify the subject and recognize which elements to leave out, or perhaps move things around to make a better composition. In other words, take advantage of your artistic licence.

Acrylics are the perfect vehicle to help you to capture the complex spirit of nature. The translucent washes of acrylic inks effectively set the mood and atmosphere, while the heavy-body colours are ideal for re-creating the exquisite textures found in landscape details, giving the viewer a tangible sense of place.

▷ **Field Patterns**
40.5 × 42 cm (16 × 16½ in)

This landscape had its starting point in reality but the painting is merely my emotional response to the scene – the white cottages surrounded by dark trees and the yellow field.

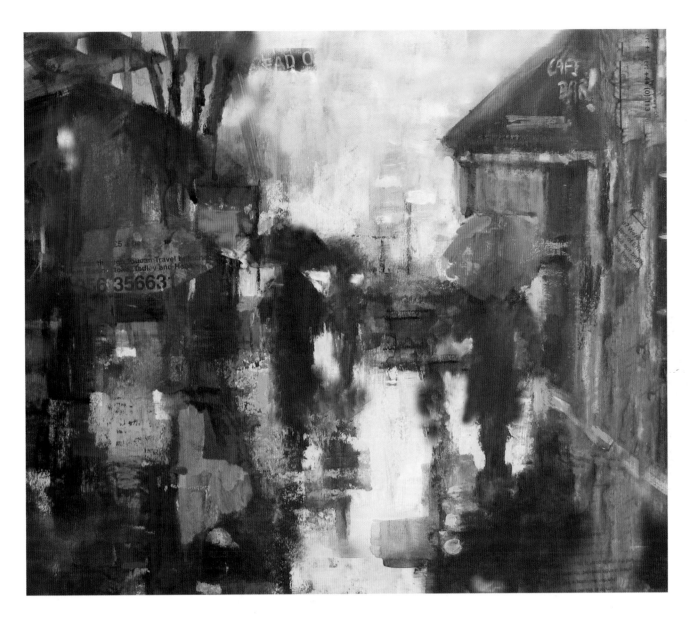

The urban landscape

The urban landscape offers the artist plenty of opportunity and great scope for potential subject matter. Whether it is the big cities with their magnificent architectural landmarks or the charming narrow backstreets of picturesque places such as Venice, with washing lines hanging out of the windows, there is much to be explored.

When painting cityscapes it is easy to assault the viewer with too much information and detail, so it is highly important to simplify and edit the scene. People are very much part of the urban landscape, but some artists prefer to zoom in on the architectural aspects or details of the buildings. You must decide which is to be the dominant factor in your painting, and whether it is the buildings or the figures that will play the most important role. Alternatively, it might be the effect of sunlight on an interesting building or something similar. Once you have established your approach you can then leave out or play down the least important components and focus on the main areas of interest.

Most artists find all the activity in cities too disruptive for *in situ* painting, so taking some photographs or making a few quick sketches will provide good reference for painting urban landscapes back at the studio.

△ **Rainy Day Reflections**
30 × 40.5 cm (12 × 16 in)

The striking feature of this urban landscape for me were the reflections of the figures on the wet pavement. The buildings and the kiosk have been abstracted to play the supporting role here.

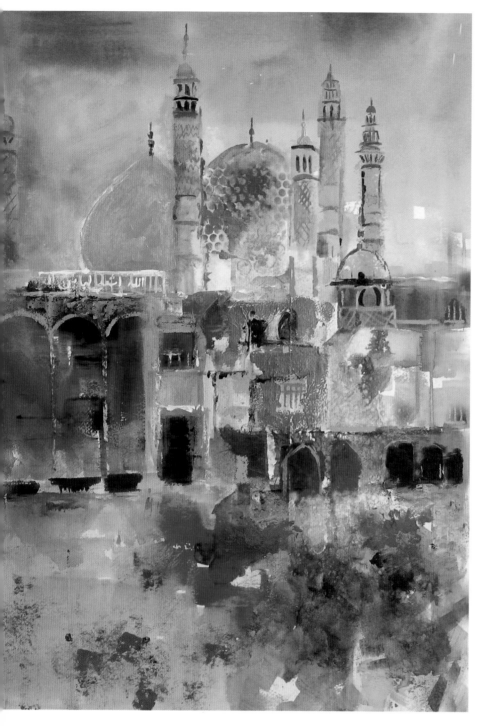

Inspired by travel

There is nothing as refreshing as the sights and sounds of a new land to tantalize the senses and get the creative energy flowing. The first time this really hit home with me was years ago on a visit to my homeland, Iran. Growing up in the capital, Tehran, I had never seen many parts of my country before. Travelling with my English husband made me see things in a different light, through the eyes of a tourist. The sight of the nomadic Ghasghai women walking in the desert near Shiraz, wearing their clashing colours of orange and sharp pink, with their long skirts and colourful headgear blowing in the wind, had such a huge impact on my perception of colour. The hustle and bustle of the bazaars, with their multi-coloured fabrics and rugs, were all clamouring to be painted.

It was this visit that first inspired me to seek out other destinations as potential subjects for painting. Although I have now visited a few, there are many places left on my wish list, and each trip I make provides fresh and exciting ideas. My trips to the Caribbean, in particular, have been the inspiration for a whole series of paintings which I have enjoyed immensely. The vibrant colours of acrylic inks and paints are perfect for re-creating the buzz and energy that I experience while travelling in these foreign lands. I can only hope that the images I bring to life will fully convey the feelings that these people and places evoke in me.

◁ **Mosque at Qom**
51 × 35.5 cm (20 × 14 in)

I adore the variety of shapes in these magnificent historical mosques. The roundness of the golden dome is beautifully balanced by the tall shapes of the minarets. The geometric patterns on the mosaics are simply exquisite.

▽ Jamaican Market
46 × 49 cm (18 × 19¼ in)

I find Caribbean markets
irresistible. They are so
colourful and full of life,
with numerous delightful
shapes and colour
contrasts to explore.

Explore further

• Look through your holiday sketches and photographs
and select one which features a townscape. Paint
this twice, first making the figures the most
dominant element and then concentrating on the
buildings and architecture.

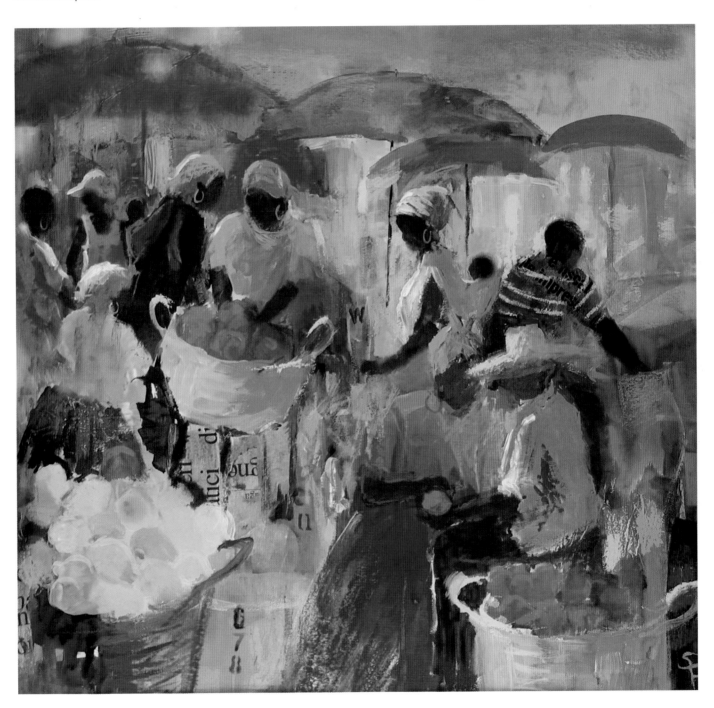

PROJECT Creating a storyboard

A storyboard is a series of images that are used to plan out a project and give an indication of how the finished work will look. It can be a useful device for artists to use when they are painting from reference material.

As it is not always convenient to paint from life, working from photographs at home or in the studio can be the next best option. Most subjects which include figures, such as beach scenes or marketplaces, are transient and can really only be captured properly on camera. However, a photograph does not always come with a ready-made composition and sometimes the solution to this when planning your painting is to use information from several different photographs. Sketches to work out the format, tonal values and light direction are also absolutely necessary in order to get the proportions right and keep frustration at bay.

Gathering your material

Choose a few related photographs and arrange them on a piece of card side by side. Determine the points that interest you, selecting from each photograph as necessary. Think about the best compositional format for your picture – landscape or portrait. Try both before you decide. Then make a little sketch to establish the tonal pattern in the scene. Once you have done this, place the sketch on the piece of card alongside your photographs so that all your reference material is at hand and you are ready to start painting. Use the photographs for colour reference.

△ **Photograph 1:
Salisbury market**

I liked the sunny feel of this photograph and was fortunate to be able to capture the flower-seller in a good position.

▽ **Photograph 2:
Salisbury market**

In this shot I managed to get two customers in a natural pose, but the flower-seller was totally out of view. To make the best composition, therefore, I decided to use both photographs as reference and also to make a sketch.

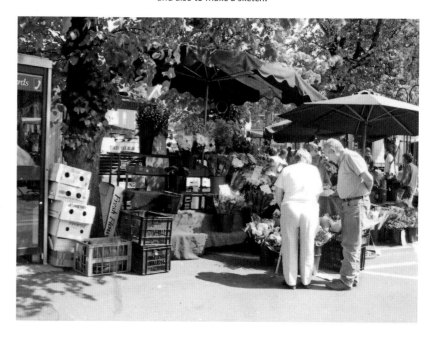

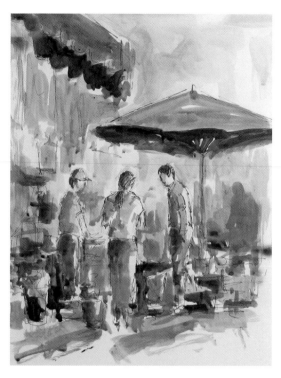

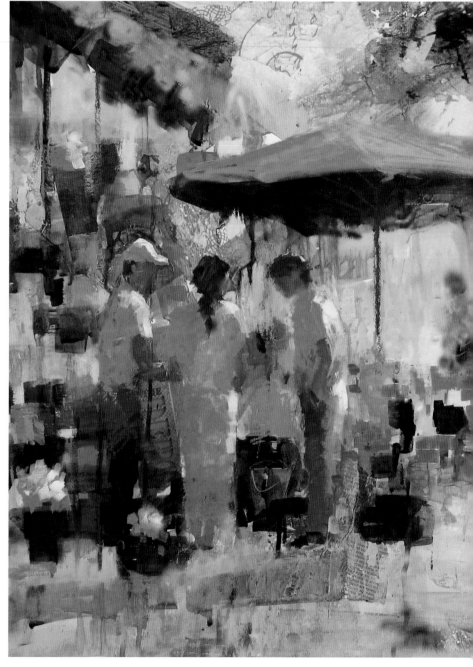

△ In my sketch, based on the two photographs, I included the flower-seller from Photograph 1 and the two figures from Photograph 2. Although both photographs were landscape in format, I found a portrait format more pleasing for my sketch.
I then applied my darks, mid tones and lights to establish the tonal pattern.

▷ **Salisbury Market Flower Stall**
51 × 40.5 cm (20 × 16 in)

I started with an underpainting of Yellow Ochre and Lemon Yellow acrylic inks to create a sunny atmosphere and then blocked in my darker values in Prussian Blue and Payne's Grey inks. Drops of Process Magenta and Olive Green inks were added in the area of the flowers, and heavy-body acrylics were used to paint the figures and add more detail.

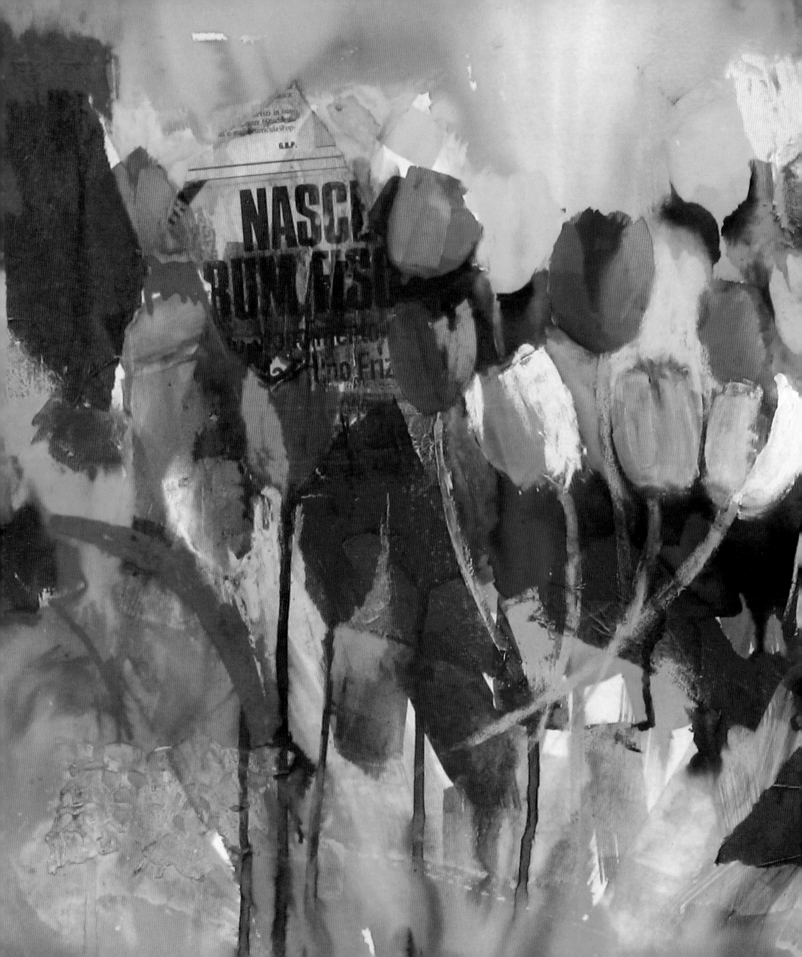

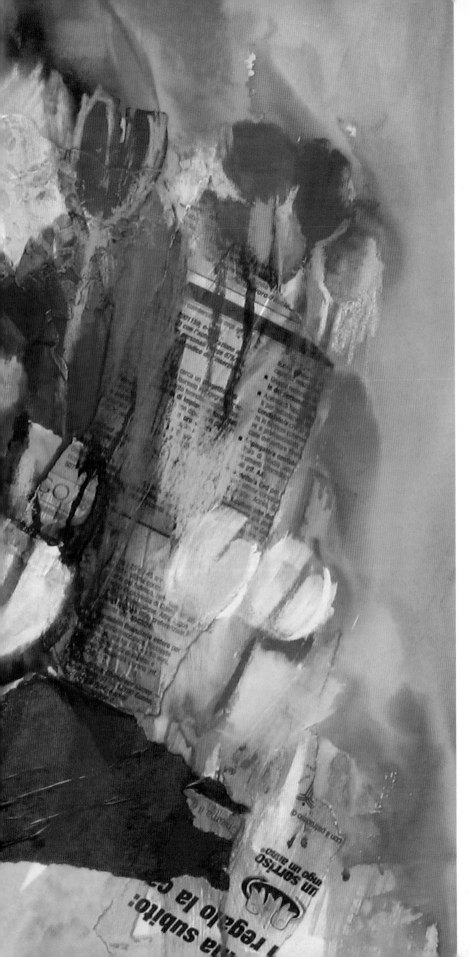

Glorious colour

For many artists nothing compares with the sensual feel of manipulating colour on paper or canvas. It is by far the most seductive aspect of painting and is the reason why many painters pick up a paintbrush in the first place. But it can also be the most confusing and complex aspect of painting, and therefore quite a challenge. Understanding the four main attributes of colour – hue, intensity, temperature and value – is vitally important, as ultimately it is how you use these, in terms of contrast, harmony and tonal balance, that will ensure the success of your painting.

Acrylic paints provide the opportunity to indulge not only in the most fabulously vibrant colours, but also in the more sophisticated subtle and subdued tones.

◁ Tulips
40.5 × 51 cm (16 × 20 in)

Mixing acrylic colours

Colour is a multi-dimensional subject with numerous books devoted to it. When it comes to painting, most leisure painters are simply concerned about how to translate their tubes of paint into successful mixes of colour. Acrylic colours may seem rather harsh when squeezed from the tube, but they can be mixed to achieve a wide range of both vibrant and subtle colours. Furthermore, the addition of white to any colour results in an infinite number of tints. I must emphasize the importance of investing in high-quality artists' colours as they will contribute significantly to your success with colour mixing and ultimately to your painting as a whole.

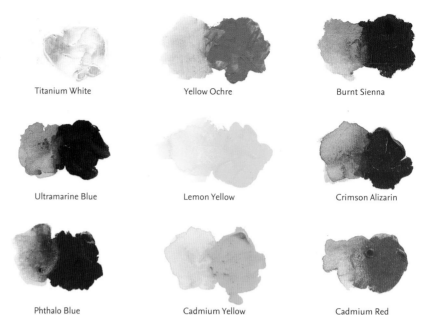

Titanium White Yellow Ochre Burnt Sienna

Ultramarine Blue Lemon Yellow Crimson Alizarin

Phthalo Blue Cadmium Yellow Cadmium Red

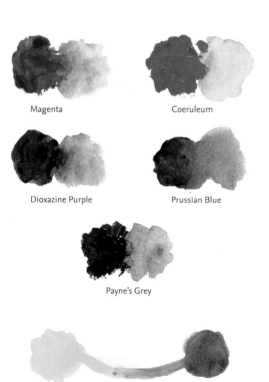

Magenta Coeruleum

Dioxazine Purple Prussian Blue

Payne's Grey

△ This basic palette should provide you with all the colours you need to mix both vibrant and muted secondary colours.

◁ You may wish to add a few extra colours to your palette, as and when you need them for a particular subject.

◁ Lemon Yellow and Phthalo Blue make a bright green, Cadmium Yellow and Cadmium Red make an intense orange, and Crimson Alizarin and Ultramarine Blue make a vibrant purple.

Colour temperature

In order to mix vibrant secondary colours it is essential to understand the concept of colour temperature. Each primary colour has warm and cool versions. The temperature is determined by the fact that each primary colour contains traces of other colours – pure primary colours do not exist in paint and pigment. This means that you need to recognize the colour bias of each primary you use when mixing your secondary colours, as this will affect the vibrancy or otherwise of your mixes.

For example, a green-bias cool yellow, such as Lemon Yellow, when mixed with an equally cool blue, such as Phthalo Blue or Prussian Blue, will make a cool vibrant green. Similarly, an orange-bias warm yellow, such as Cadmium Yellow, when mixed with an equally warm red, such as Cadmium Red, results in an intense orange. On the other hand, a vibrant purple is produced by mixing a warm blue, such as Ultramarine Blue, with a cool red, such as Crimson Alizarin.

Key colour mixes

In the next few pages we will look at some of the principal mixes that are necessary to achieve a well-balanced colour scheme for your paintings. It is important to remember that colours do not exist in isolation – every colour added or tone adjusted within a painting will have an impact on the others.

◁ **Flower Medley**
35.5 × 35.5 cm (14 × 14 in)

This painting is predominantly made up of primary and vibrant secondary colours. The bright flowers, however, are set against a calm and muted background. Their colours are repeated to create balance.

▽ **Snowdrops**
30 × 30 cm (12 × 12 in)

I felt a subdued background was most suitable to show off the whiteness of these snowdrops. The darks in the centre of the arrangement are really important to emphasize the pale flowers. I used the same light greys as in the background for the shadow areas of the flowers.

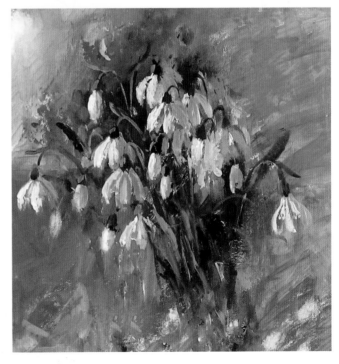

Studio tips

- To begin with, limit your colours to the few that you really need. Having too many tubes of colour can be more confusing than helpful.
- Payne's Grey is already a mix of two or three colours, so it is best not to add too many other colours to it.

Striking combinations

'Every colour is the friend of its neighbour and the lover of its opposite.' (MARC CHAGALL)

Complementary colours placed next to each other in a painting create striking combinations. These colours – red and green, yellow and purple, blue and orange – are immediately opposite each other on the colour wheel, and they enhance and intensify each other. They almost vibrate with a kind of energy that adds movement and vitality to a painting. The Impressionists were masters in combining

complementary colours and exploiting their juxtaposition to create magnificent visual feasts.

To produce more dynamic paintings it is important to remember this interaction between colours. Colour perception differs from one artist to another and as there are so many tones in which each complementary may be used the combinations of these colours can be infinitely varied. Colour is a relative concept and the relationship between colours has great impact on the overall dynamics of a painting. Remember that by adjusting one colour and its tone within your painting you may also need to reconsider the others.

When added together in equal proportions complementary colours can also be used to neutralize each other. The best way to desaturate a colour or darken it slightly is to add a little of its complementary colour to it.

▷ Complementary colours such as Cadmium Orange and Light Blue Violet make a striking combination when placed next to each other in a painting.

▷ **Three Pears**
35.5 × 35.5 cm (14 × 14 in)

This shows clearly how two complementary colours can make a striking combination. I painted the pears with bright Vivid Lime Green to create maximum impact against the Cadmium Red background.

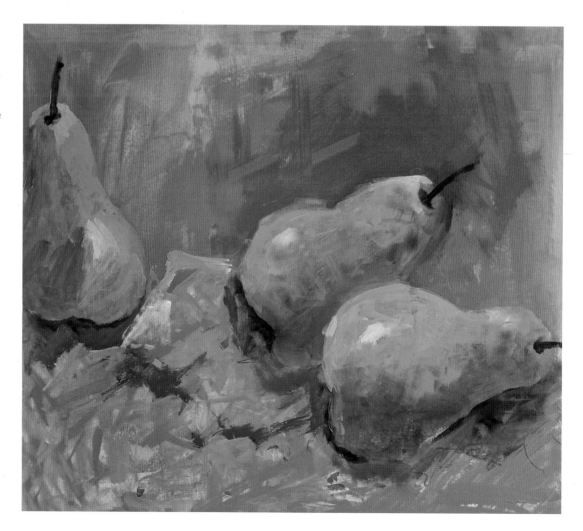

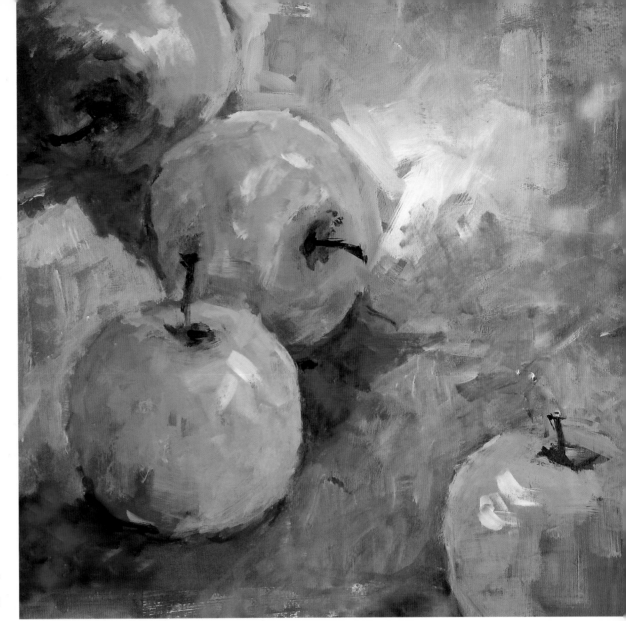

▷ **Granny Smiths**
35.5 × 35.5 cm (14 × 14 in)

This painting is predominantly made up of harmonious colours. I used yellow-green, green and blue-green for the apples, and the eye makes a smooth transition from these to the blue of the tablecloth in the background. The small specks of red showing through break the monotony and add a little zing to the painting.

▷ These neighbouring colours on the colour wheel make a harmonious combination.

Harmonious colours

Harmonious or analogous colours are those which are next to or near each other on the colour wheel, such as blue, blue-green and green. Unlike the complementary colours, harmonious colours create a feeling of calm and tranquillity, as the eye makes a smoother transition when it travels from one colour to another. Nature does this to perfection: think of

the fabulous colours in a twilight sky, with its combination of purple, blue and magenta, or the yellow, orange and magenta at sunset.

Combining harmonious colours with one complementary hue is another way of making a striking combination. A painting consisting of too many complementary colours can be in danger of creating visual noise and chaos. Likewise, too much harmony can become monotonous, disengaging the viewer. Fine-tuning the colour balance is vital to the success of your painting. A dynamic image therefore needs to provide a visual equilibrium by finding a happy medium between the energy of complementary colours and the respite provided by harmonious ones.

Mixing neutrals

Although I seem to have acquired a reputation for my use of bright colours, I adore the neutrals too and consider them the backbone of any painting. These are the wonderful unassuming and quiet tones which support the more vibrant hues and make them shine, at the same time providing a respite from the riot of colour. True neutrals, such as black, white and neutral grey, are achromatic colours, which means they have no hue.

The natural tendency with the inexperienced artist is to mix black and white to achieve a grey. However, a mix obtained in this way has no colour bias and is rather flat, cold and uninteresting. Mixing neutrals by combining the three primaries or two complementary colours will give you an infinite number of the most delicious greys, browns and lively near-blacks. By tweaking the proportions you can make your mix warmer or cooler, or whatever else you want it to be. These mixes are called semi-neutrals as they have a subtle bias towards a particular colour.

My main recommendation to you is to mix your greys or semi-neutrals from the primaries that already exist in your painting in order to achieve maximum harmony and unity. Make a note of your more successful mixtures for future reference.

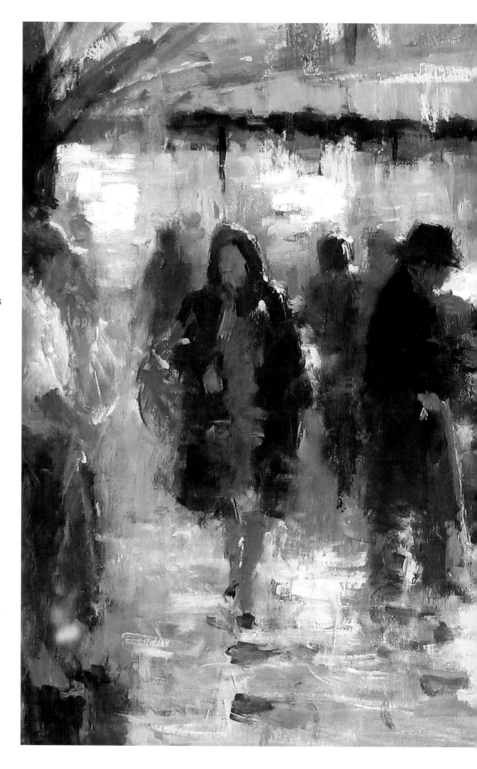

▷ **Rainy Day Market**
35.5 × 25.5 cm (14 × 10 in)

Apart from the few touches of Turquoise this painting is made up of a whole range of greys and browns, using heavy-body acrylics. I mixed different proportions of Coeruleum, Lemon Yellow and a dab of Magenta to create a variety of greys. The darker tones are a mix of Ultramarine Blue and Burnt Sienna.

Mixing greens

Green is a problematic colour for most inexperienced artists, and reaching for the ready-made colours seems an easy option. With a few rare exceptions, manufactured greens are often quite harsh and unnatural, but they can be easily modified so do not discard them if you have already acquired some. Mixing your own greens, however, is definitely the best and most satisfying option.

Mother nature is a master colourist and the number of greens a landscape painter is faced with can be overwhelming. The beauty of these greens is in their variation of tone. Yellow-greens, dark greens, lime greens, blue- and silver-greens and many more come together in nature in the right tone to create perfect balance and harmony.

Mixing just one even green on the palette and applying it throughout your painting can look boring. It is best to make a base mixture and then lighten or darken it, and make tints and other mixes as required. Mixing colour on your chosen support is also a good way of applying a fresh and varied colour. Prussian Blue and Lemon Yellow make a very palatable green, which can range from a very dark to a lovely light colour. By adding more blue and a little white you can create a blue-green that recedes beautifully, making it appropriate for suggesting distance. Phthalo Blue and Lemon Yellow are equally good partners; if the mix is slightly too acid at first, a little dab of red, such as Crimson Alizarin or Cadmium Red, will modify and darken the mixture. Olive green is a colour that I usually avoid, but as an acrylic ink it is actually a very nice and useful colour.

△ Prussian Blue and Lemon Yellow make a lovely dark-green base mixture (*centre*), which can then be adjusted as required.

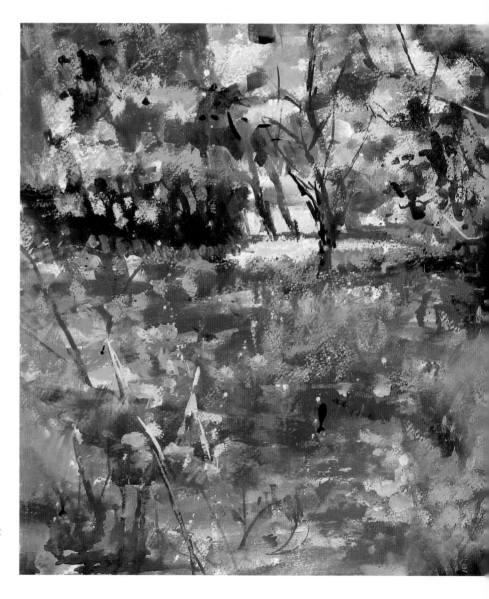

▷ Bluebell Wood
30 × 30 cm (12 × 12 in)

Here Prussian Blue and Lemon Yellow were mixed to make the base green colour. From this I made a number of different greens by adding a little more blue or yellow as required, and a few tints by adding Titanium White.

Mixing dark tones

Dark tones create depth and structure in a painting and without them it is impossible to portray the effect of light. Inexperienced artists often tend to shy away from using dark colours, which can result in paintings that appear lifeless through lack of a correct tonal structure. This is especially true in watercolour painting, but when working in acrylics you can be more daring with your darks since you can rectify any unsatisfactory muddy colours by painting over them.

Although some artists use black successfully in their paintings, it is a rather dull and dead colour. There are much livelier near-black mixes that you can make, such as the classic combination of Ultramarine Blue and Burnt Sienna, and by altering the proportions of these two colours you can mix a warmer, browner black or a cooler blue-black colour.

Should you need a lighter grey, to create harmony I suggest adding white to the existing dark mixes in your painting, rather than introducing yet another colour. The use of Payne's Grey has always been quite controversial, but as a dark tone used in the right amount and context it can be both useful and beautiful. Mixing Crimson Alizarin and Hooker's Green makes a very nice rich dark green or dark purple, according to the proportions of each colour used in the mix, which is great for garden and floral paintings. So do not be afraid of the dark and give your paintings substance by including the right balance of lights, mid tones and darks.

▷ Ultramarine Blue and Burnt Sienna make a lovely near-black, which is much livelier than pure black.

▷ Crimson Alizarin and Hooker's Green make a rich dark, suitable for areas of foliage in landscape or garden paintings.

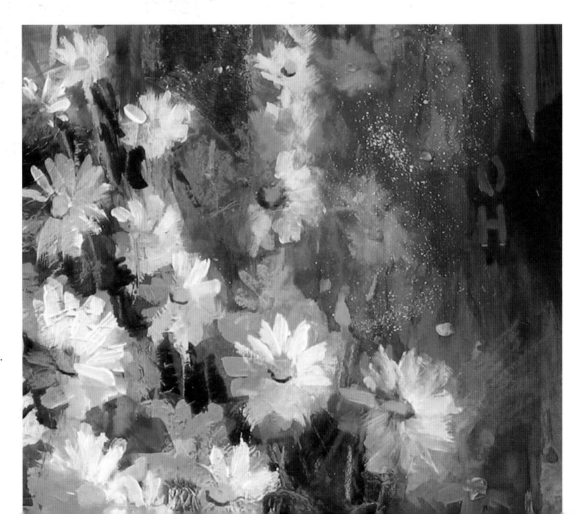

▷ **Daisies**
20 × 20 cm (8 × 8 in)

The white daisies in this painting are offset against the darks in the background. Without these the flowers would not command as much attention. There are also a number of shadow colours on the flowers themselves.

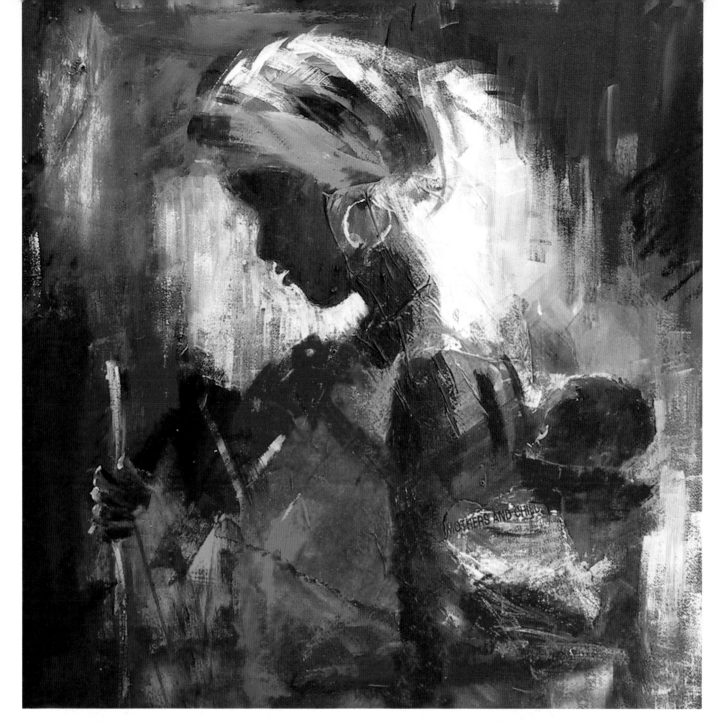

△ **African Mother**
40.5 × 40.5 cm (16 × 16 in)

Here the dark tones play a
particularly important role.
The striking light behind the
figure is offset against the
shadowy background, which
also shows off the colourful
clothes and head-dress to
advantage.

Explore further

- Mix a series of greys, each time using a different
 blue, red and yellow, and varying the proportions.
 Repeat the same exercise but this time mixing greens
 and darks, using the suggested colours in this
 chapter. Make charts of the most successful mixes
 and keep them for future reference.

Painting the seasons

The seasons immediately conjure up images of certain colour combinations. Light quality and elemental changes associated with different times of the year have been a great source of inspiration for many artists throughout the ages. It is lovely to take advantage of the unique characteristics of each season by recording and gathering ideas for paintings. Working on location throughout the whole year is a great practice and offers a wealth of subject matter, but equally making sketches or taking photographs on a sunny summer's day on the beach is an ideal way to provide you with a cheerful subject to work on back at the studio on a gloomy winter's day.

Spring

The greyness of winter gives way to a riot of vivid colour as nature starts to renew itself at the equinox. The beautifully fresh yellow-greens and blue-greens of new foliage and the magenta of cherry blossom offer plenty of ideas for subjects. The striking colour contrasts created by the scattering of purple and yellow crocuses, irises and daffodils, and of course the magical phenomenon of a bluebell wood are all hugely inspiring for a painter. Spring offers you both harmonious and complementary palettes in abundance to work with.

◁ **Summer Hedgerow**
20 × 24 cm (8 × 9½ in)

A simple study of a little patch of late-summer hedgerow flowers – yellow, white and little dabs of red set against the bright blue of a summer sky.

△ **Crocuses**
25.5 × 25.5 cm (10 × 10 in)

A carpet of crocuses in the complementary colours of yellow and purple is one of the early signs of the arrival of spring and makes a perfect subject for the artist.

Summer

Summer is the season of heat – even the yellow light of the sun takes on a more orange glow and on sunny days the sky turns a more vivid, brilliant blue. With everything in bloom, the trees fully clothed, and the countryside and hedgerows rich with wild flowers there is plenty to inspire the artist. Of course, the beach and the seaside make perfect subjects during the summer months. Fields of golden corn and harvested wheat later on in the season also create great opportunities for the artist to play with shape and colour.

Autumn

Autumn is a symphony of rich hues, the most breathtaking of all the seasons in terms of colour. The golden yellows, rusty oranges and fiery reds of autumn leaves, along with the remaining green ones, create a striking contrast against a blue sky. In my garden both the Acer and the Virginia creeper put on a magnificent show as they burst into a profusion of colour. As well as the scattering of colourful leaves, the autumn berries and the remaining flowers make autumn perhaps the most inspiring of all the seasons for a painter.

▽ **Winter Shrub**
25.5 × 25.5 cm (10 × 10 in)

In winter scenes I often use washes of Yellow Ochre and Process Magenta acrylic ink to add a warm glow in contrast to the cooler blues and grey shadow areas on the snow.

▷ **Autumn Leaves**
20 × 25.5 cm (8 × 10 in)

Here washes of acrylic ink in autumn colours were flooded in wet-into-wet and left to dry. I then painted the negative shapes between the foliage to define the individual leaves.

Winter

I love the greyness of winter; in the gloominess of cold and overcast days lies a whole palette of beautifully muted tones that complement and emphasize the starkness of the skeletal trees. The faint yellow light of winter sun on a frosty morning has inspired many artists, but perhaps the most striking feature of the winter months is snow. The myriad of lovely violet-grey, blue and purple shadows that lie over its white surface make a wonderful subject for the artist.

Studio tips

• Cut strips of colour from magazines and stick them down in your sketchbook. Group them in categories — seasonal, harmonious and complementary colours. This makes a wonderful reference for choosing colour schemes for your paintings.

The colour scheme of your painting has a direct result on the overall mood of your work. Many artists, past and present, have repeatedly painted their favourite subject using a variety of colour schemes. The Impressionists often painted the same subject at different times of the day or in a different season, which had great impact on the mood and atmosphere conveyed in their paintings. This idea can be explored whether you paint representational or abstract subjects.

Using different colour schemes

For this project, take a subject such as a beach scene or landscape and paint it several times, portraying it in both morning light and at dusk. Use a different colour scheme and change the dominant colour each time. Note the difference between using high-key colours and more subdued tones.

Then paint the same landscape, or another one if you prefer, in different seasons, again varying your colour scheme appropriately. You may discover that the colours or characteristics of one particular season suit your image better than others. This is also a good exercise for discovering your natural inclination towards certain colour schemes and for finding your preferred palette of colours.

△ **Venice by Day**
30 × 30 cm (12 × 12 in)

In this painting I wanted to portray the midday sun and its gleaming reflection on the water. I used warm, golden yellows for the sunlight and a predominantly grey colour scheme for the water and the buildings.

▷ **Venice at Night**
30 × 30 cm (12 × 12 in)

Using blue, purple and sienna in this version totally changed the whole atmosphere of the painting, capturing the atmosphere of early evening.

◁ **Spring Blossom**
23 × 25.5 cm (9 × 10 in)

The Vivid Lime Green set against bright Scarlet Red, and the dabs of Cadmium Orange and Brilliant Blue in places, create striking combinations. These are counterbalanced by the more harmonious colour scheme of the blossom, with its softer blues, grey-blues and purples. Little dabs of red and green show through to unify the image.

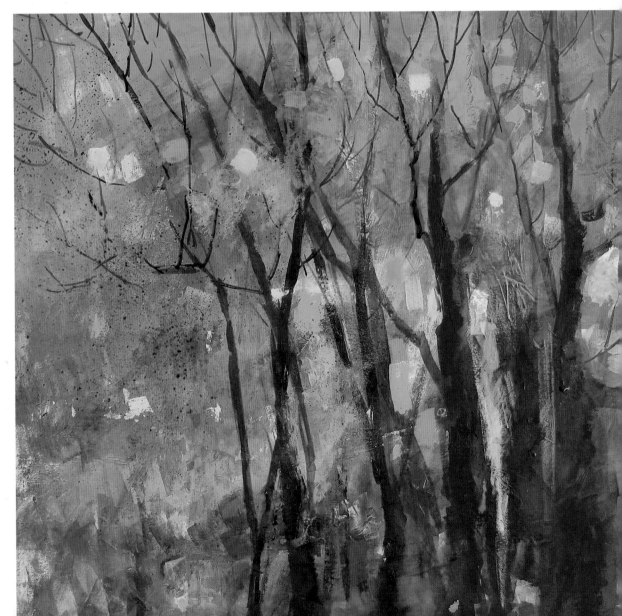

▷ **Autumn Colours**
30 × 30 cm (12 × 12 in)

This painting is a riot of exaggerated autumn colours set against the silhouetted trees. The intense oranges make a sharp contrast with the blues, as do the yellows with the purple-magentas.

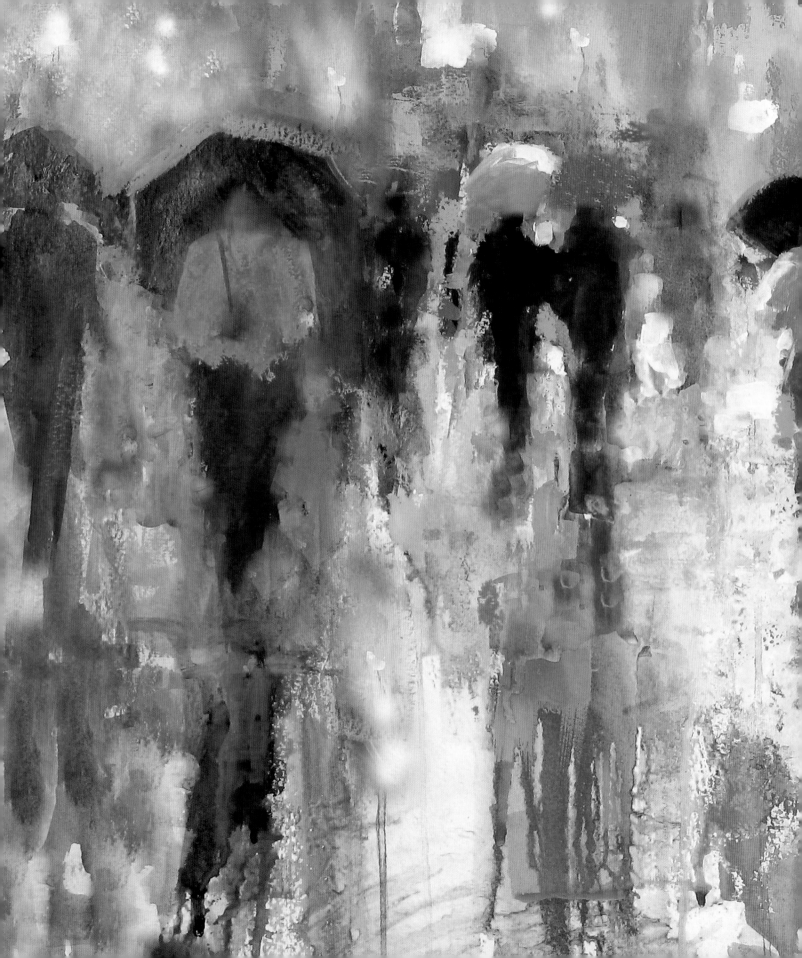

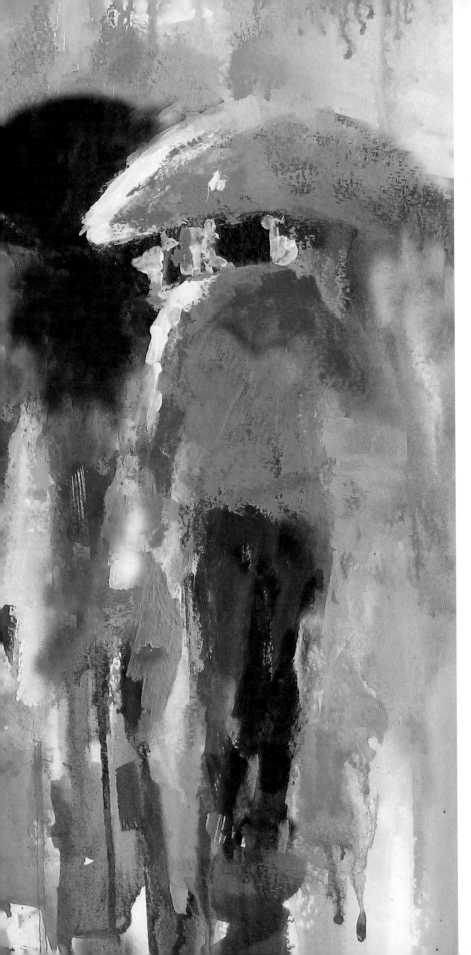

Dramatic lighting

While the tranquillity of paintings with subtle tonal change can be very appealing, there is no doubt that paintings with strong contrasts of bright light and dark tones create maximum visual impact. The play of light against dark provides an element of drama and is one of the most important ways of achieving a dynamic painting.

Light is the key element that brings a painting to life; without it the image becomes as dull as an overcast day. The intangible quality of light, however, makes it one of the most challenging subjects for the artist. In order to paint light effectively you need to be able to recognize and paint its opposite force – the darker values – and in this chapter we look at a few ways of capturing light and tonal contrast.

◁ Rainy Day
46 × 56 cm (18 × 22 in)

The importance of tonal values

Put simply, tone is the lightness or darkness of any colour. If you look around you, you will see that all objects are separated from each other by their colour and, most importantly, the tonal value of that colour. Learning to view your subjects in terms of their colour value is a big step towards creating paintings with a sound tonal structure.

One of the most important design elements and attributes of colour, tonal value is the factor that turns simple shapes into forms, defining the boundaries between each shape and solidifying the painting as a whole.

As we have already seen, dark values also add depth and substance to a painting, and are essential in helping to convey light. In their quest to find the right local colours, inexperienced artists can sometimes overlook the importance of correct tonal values, which can result in an image looking flat, lifeless and lacklustre. In the words of the notable Canadian artist Harley Brown: 'In painting as in life you can get away with a great deal as long as you have your values right.'

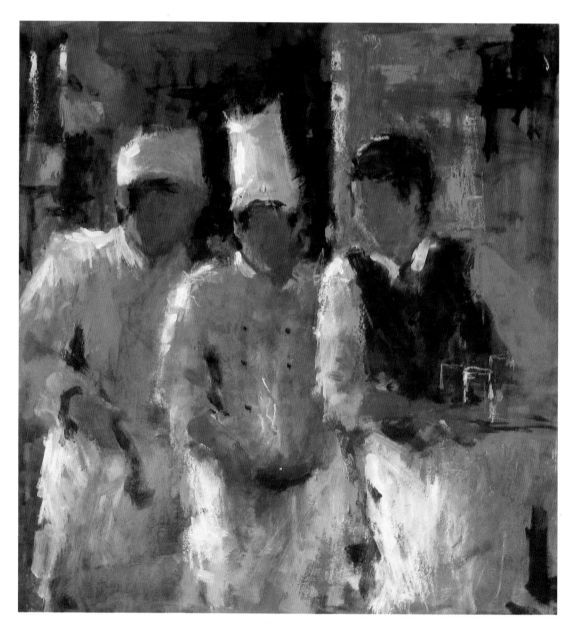

▷ **Chef's Surprise**
25.5 × 25.5 cm (10 × 10 in)

There are numerous shadow colours in white objects or garments – painting these is a great exercise in recognizing tonal values. Here the dark background provides the ideal backdrop for the whites to show up.

Seeing the tonal values

When observing and sketching your subject from life the best way to assess the tones is to half close your eyes. This eliminates the detail and breaks down the image into light, dark and mid tones, making it easier to ascertain and establish the right tonal balance. Learning to structure a painting by blocking in a pattern of tones, initially ignoring other elements of the subject, is a huge leap forward on the road to becoming an artist.

It is easier to recognize and create a tonal pattern in pencil or charcoal sketches because of the absence of colour. Similarly, if you are painting from a photograph, take a black-and-white copy of it to help you to gauge the right tones. The tendency to concentrate on the subject itself, or its colour, can get in the way of objectively looking at your subject in terms of tonal structure; but if you turn the photograph or sketch upside down or on its side this may help you to focus on the tonal pattern first. As your experience grows you will become less concerned with the local colour of the subject and more aware of its tonal structure; and with patience, practice and perseverance this will become a natural process in the creation of your painting.

Studio tips

- It is a much easier task to block in your tonal structure in acrylic colours. Light tones can be painted over darks so there is no need for outlines or any forward planning.
- Painting monochromes will really help you to understand how to assess correct tonal values.

▽ **Musicians**
25.5 × 20 cm (10 × 8 in)

The tonal values in this painting range from the lightest light of the white areas to the variety of subtle greys in the background and the rich black of the musicians' suits.

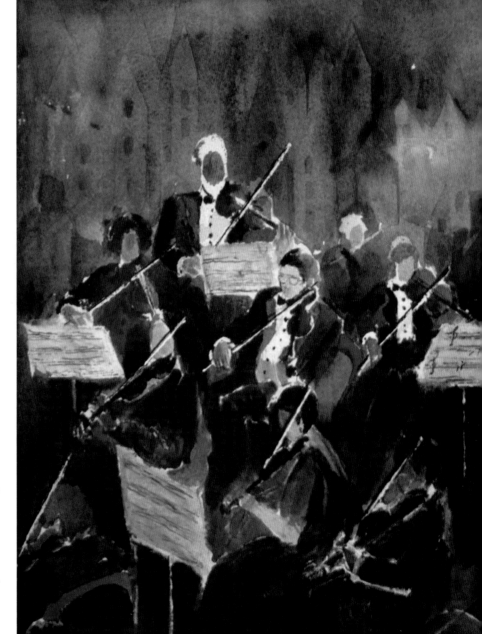

Capturing light

Capturing light in a painting can be a very challenging task and doing this with conviction takes time and much practice in observation, analysis and application of techniques. The effect of light and the resulting cast shadows can make the most mundane and ordinary subject spring to life.

There are so many ways of introducing light into a painting. The primary concern is the source and direction of the light. The way in which it falls on a particular subject is also important. The quality of light varies from place to place, at different times of the day and in every season, so close observation is necessary. The gentle light of the early morning sun, for example, is totally different from the much stronger midday light on a sunny day.

The transient quality of natural light poses the main difficulty for the artist. Rapidly changing light and the consequent changes in cast shadows can alter the whole dynamics of a work in progress, leaving the artist frustrated. The only way a painter working *en plein air* can gather enough information to finish their painting is by making detailed sketches and notes and taking a few reference photographs as they work.

For some artists the subject itself can become secondary to the way in which the light in a scene is portrayed. From the technical point of view, this is so much easier when you are working in acrylics: you can apply light colours over dark, and you can choose whether to reserve any white paper or use white paint and tints for the light areas in your painting.

▽ **After the Match**
35.5 × 40.5 cm (14 × 16 in)

My fascination here was with the white clothing of the cricketers, which offered the opportunity to play with the shadow colours and the effect of light on their uniforms and hats. The whiteness of the clothes is only obvious where the light shines on them.

Capturing mood and atmosphere

When a painting is the genuine response of an artist to a particular subject the mood and atmosphere are an inherent part of the creation of the work. Its authenticity will transport the viewer to share that vision and will evoke the same response. Paintings with little or no tonal contrast generally convey a feeling of calm, while stark contrast between the light and dark passages, especially at the main point of interest, creates a more dramatic impact.

Sometimes the mood is transferred through the narrative within the subject matter; for example, happy or sad faces send an immediate and clear visual message. A painting's colour scheme also plays a big role in capturing the mood. High-key and bright colours generally make happier images whereas dark colours tend to convey the sombre quality of a moody painting.

The texture of the paint and the way in which it is applied can affect the mood of a painting, too. Smooth wet-into-wet colour washes create calm and atmospheric paintings, while vigorous and energetic paint application adds movement and vitality and is visually invigorating. You can take advantage of the different consistencies of acrylic paint to capture the right mood, by using a combination of soft and atmospheric washes of ink and more textured areas painted with the high-viscosity colours.

Explore further

- Using an underpainting is an effective way of setting an overall ambience. Paint a landscape subject on a support tinted with a Yellow Ochre underpainting. Allow the underpainting to show through subsequent layers to create a high-key and sunny atmosphere. Then paint the same subject again, but this time use a subdued blue-grey underpainting for a more moody and sombre atmosphere. Also experiment by using a complementary colour for your underpainting, such as red for a predominantly green landscape painting. Make a note of each effect for future reference.

◁ After the Rehearsal
40 × 25.5 cm (15¾ × 10 in)

This *contre-jour* painting of dancers captures the mood of the studio with shafts of light behind the dark shadowy figures.

▽ Midday Sun
35.5 × 37 cm (14 × 14½ in)

The placid subject, cool colour scheme and lack of contrast create a feeling of calm and tranquillity in this seascape.

Night scenes

The urban landscape comes to life at night. The colourful lights of neon signs, cars and other aspects of city life look deliciously exciting, especially to an artist. In the dim light and with the absence of much colour the figures, buildings and trees lose their details and take on a dark, shadowy and rather enigmatic appearance. Shafts of light seeping between the dark figures create magnificently dramatic effects.

Lit-up shop fronts and doorways with people hurrying by and narrow, dimly lit backstreets are all fascinating subjects, full of potential for playing with the drama of light and dark. However, be careful not to create visual 'indigestion'; establish just one dominant factor and play down the rest. Try painting a series of the same scene, focusing on a different aspect in each one.

The weather can often add an element of interest and drama to the whole scene, too. Rain brings out the wonderful shapes of umbrellas, and the fabulous reflections on the roads and pavements. Wind creates a feeling of movement. Mist and fog throw a veil of mystery over everything. The white flakes of snow in an evening scene are quite enchanting.

In the countryside moonlit landscapes can make eerie and atmospheric subjects. With such a soft and defused light source, choosing the right colour value is really important for the painting to ring true. Samuel Palmer was a master at depicting moonlit landscapes; his *Harvest Moon* is a great example.

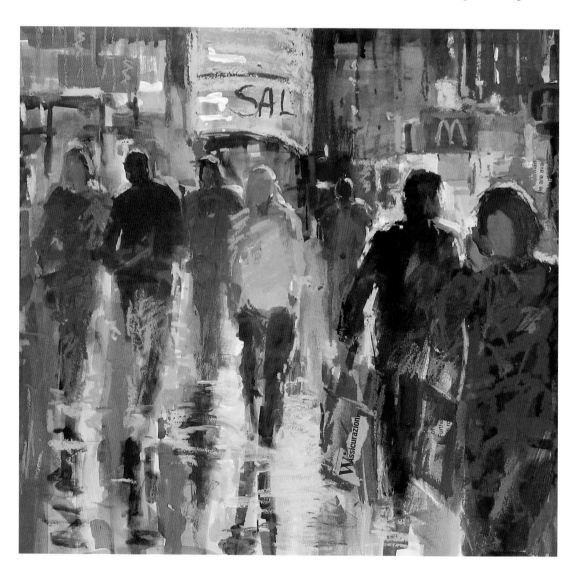

▷ **Evening Shopping**
38 × 40.5 cm (15 × 16 in)

This London scene is my response to the colourful lights of a typical high street in the evening. The dark figures provide a respite from the otherwise busy areas of colour and reflections.

Interiors

Interiors have always fascinated me – the warm glow of artificial lighting, the inherent cast shadows and the dark corners make for incredibly dramatic and compelling subjects for the artist. This is especially true of interiors such as wine bars and restaurants, where the subdued lighting gives figures and objects an air of mystery and ambiguity, with plenty of subtle lost and found edges that are a gift to an artist. Colours are often deeper and richer, and the dark tonal values against the lightest tones of the artificial light source can create the most dynamic effects. Whereas an artist has little or no control over natural sunlight, artificial light provides plenty of scope for your input.

Equally, a stream of sunlight coming through an open doorway or window can throw interesting light on objects in a room and produce beautiful shadows full of reflected colour. Take some time to explore your own familiar surroundings – you will probably find enough subjects indoors to keep you inspired for a lifetime!

Studio tips

- For maximum dramatic effect, highlight the key element or focal point in your painting.
- To create depth when painting a still life, or a life model, use a cooler fluorescent light source at the back and a yellower light source in the foreground. The cooler light makes objects appear further away.

Tone turns shapes into forms and helps to translate the three-dimensional world on to a two-dimensional surface. Recognizing tonal values is vital in order to give your painting a sound compositional structure. Some artists choose tonal value as the most dominant factor in their work and the impact of their images is dependent on the contrast of light and dark. Such is the power of correct tonal values that you can disregard local colour altogether, choosing a limited colour palette for most subjects without compromising the integrity of your painting.

There are two exercises in this project: the first one will help you to gauge the correct tonal values of your subject matter; the second one will show you how to see colour in shadow areas.

Recognizing tonal values

Either choose one of your tonal sketches or turn a favourite photograph into grey scale by taking a black-and-white copy of it or desaturating the colour in a computer programme such as Photoshop. This will make it so much easier to identify the lights, mid tones and darks in the subject. Mix a grey using complementary colours, or choose another colour, and paint the subject in monochrome, ensuring you include the full range of tones from light to dark.

Once you have done this, paint the subject again, but this time in full colour. Reproduce the grey scale shown here and compare the value of the colours in your painting against it.

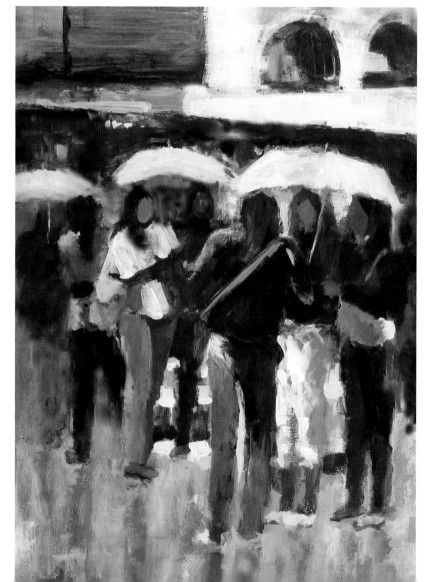

▽ **Umbrellas, Piccadilly**
28 × 23 cm (11 × 9 in)

For this painting I chose a limited palette of Ultramarine Blue, Burnt Sienna and Titanium White, and mixed a range of greys from very dark to almost white. By half closing my eyes I was better able to judge the differences between the tones. I blocked in the tonal shapes first and then added the detail to pull the painting together.

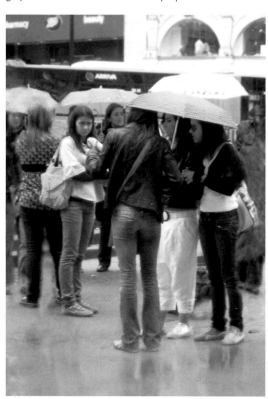

△ To assess the correct tonal values of the colours in your painting you can measure them against a nine-step grey scale as shown here.

▽ A black-and-white photograph such as this, which includes so many variations in tone, is ideal for the purpose of this exercise.

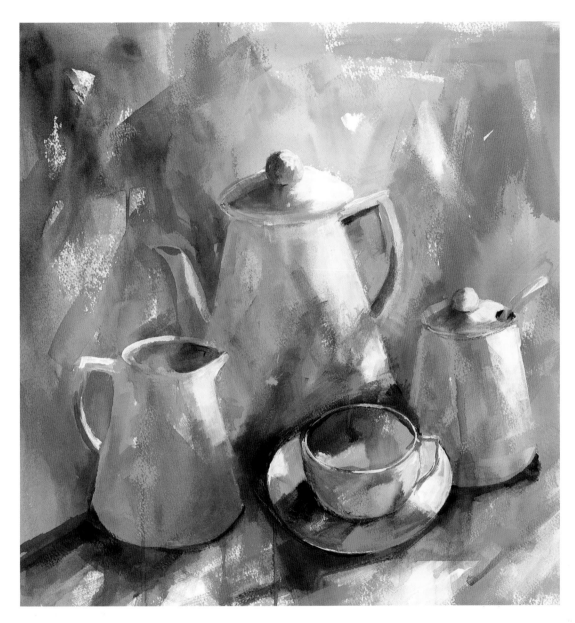

◁ **The White Coffee Set**
40.5 × 38 cm (16 × 15 in)

These objects were lit from
the right-hand side. I chose
three shades of blue acrylic
ink, Prussian Blue, Turquoise
and Marine Blue, and
flooded these over the paper,
using the darkest value of
Prussian Blue in the deep
shadow areas. I used
Titanium White soft-body
acrylics to reinforce the
whiteness of the objects
where they were highlighted.

Seeing colour in shadow areas

Painting white objects is a great exercise for
learning how to see tonal changes and read colours
in shadow areas. White objects are full of delicious
greys and other shadow colours; they are pure white
only where they are directly hit by light.

For the second part of this project, set up a still
life consisting of white objects. Either place it near
a natural light source or, better still, light it with
artificial light. Make a tonal sketch by half closing
your eyes to assess the values. Then choose three
shades of one colour, such as purple, blue and grey,
for the shadow areas and the background, making
sure that you include a good range of dark, middle
and light tones. Limiting your colours will help you
to concentrate on the tonal range within just one
colour spectrum until you get to grips with the
concept of tone. Using colour in this way makes for
a more interesting painting than if you were to use
black, white and a grey mixed from these two colours.

OTHER VIEWPOINTS

The three paintings featured here are fine examples of how to create drama in your painting with a strong contrast of light against dark. The subjects I have chosen to include are varied in style to help and inspire you, first to assess the correct tonal values, and second to capture the effect of light in your paintings whenever possible.

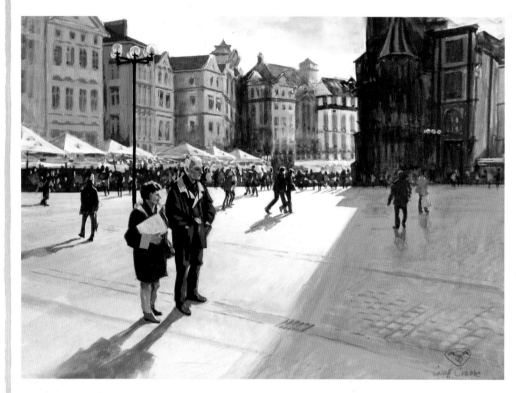

◁ **Prague**
GEOFF CRABBE
28 × 38 cm (11 × 15 in)

The shadow area on the right-hand side of this painting plays an important role in portraying the sunny atmosphere of this townscape. The elongated shadows of the figures add to the drama.

▷ **Quiet Backwater on the Test**
LIZ SEWARD RELFE
41 × 41 cm (16¼ × 16¼ in)

This painting is saturated in mood and atmosphere. Liz has eliminated much of the detail and skilfully drawn the viewer's attention to the contrast of the group of trees against the light backdrop.

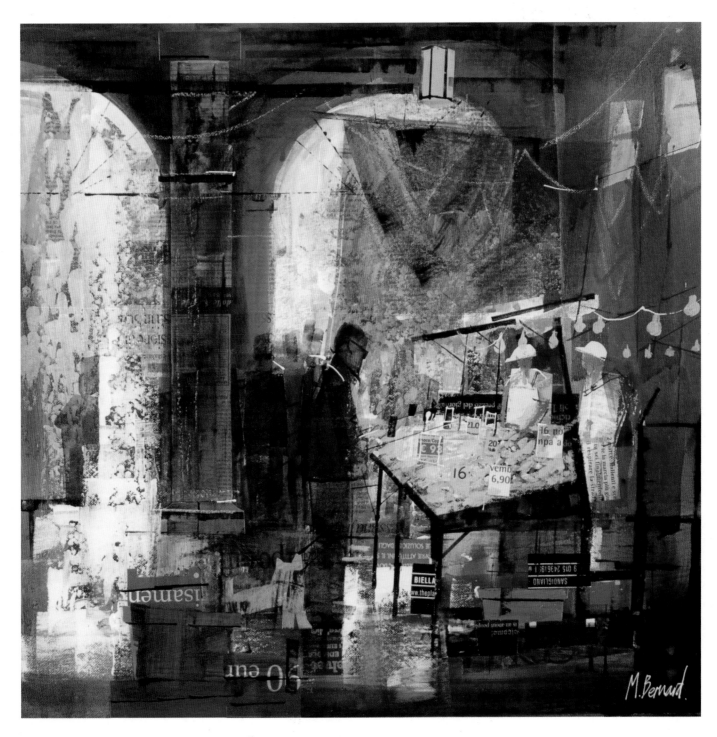

△ **Fish Market, Venice**
MIKE BERNARD
51 × 51 cm (20 × 20 in)

I love the colour scheme of this painting. The rich
dark reds and browns used for the interior of the
market emphasize and make a great contrast with
the white light seeping through the arches.

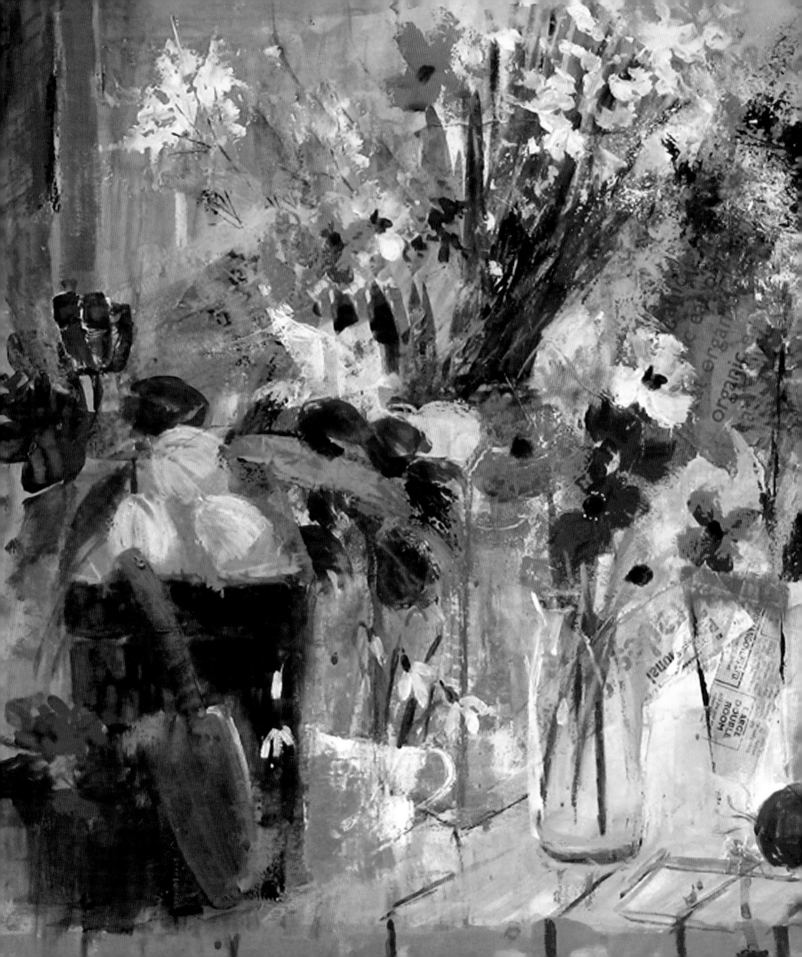

The design element

The elements of design include line, shape, space, colour, value and texture. These are the artist's tools for structuring the composition of their paintings. The principles of design – balance, emphasis, unity, harmony, variety, proportion, movement and rhythm – deal with the aesthetics of painting. To a great degree, these elements and principles are used instinctively by most artists. However, by analyzing and consequently gaining a deeper understanding of them you will be rewarded with images that not only have a solid visual coherence but also clearly convey your emotions to your viewers.

In this chapter we will look at some of the most important elements which, if used confidently, will help you to create more dynamic paintings.

◁ Greenhouse Corner
46 × 61 cm (18 × 24 in)

Composing your picture

Composition is the pleasing arrangement of the components of a painting, and it can be achieved with the help of the elements and principles of design. A successful composition both attracts the viewer and engages him fully with the painting. There are no hard and fast rules as such, but a few simple guidelines will help you initially until composing becomes second nature to you.

• Do not be a slave to your source material. Use thumbnail sketches to decide what you need to add, omit or move to make a better composition.
• Although not every painting has a focus, most compositions benefit from a strong point of interest. Divide each side of your support into thirds and join these with horizontal and vertical lines; each of the four intersections is a good place for your focal point. This is known as the rule of thirds. Place the element that you wish to emphasize – it could be the strongest tonal contrast, the largest shape, and so on – at the point of interest.
• Always place the horizon line a third of the way up or down your painting; if you place it in the middle you can cut the picture in half.
• The subject should occupy the picture plane comfortably – do not place it with too much space around it as it will become insignificant. By allowing one or two components to be partially out of the picture area, you can suggest the existence of life beyond the confines of the painting.
• Create harmony by repeating similar lines, shapes, tones, colours or textures. At the same time, add

▽ **Cornish Beach**
23 × 30 cm (9 × 12 in)

The two figures in the deck chairs create a strong point of interest in this painting and lead the eye to the smaller figures in the distance. There are two quiet areas, at the back of the painting and in the foreground, to provide respite from the busy middle section.

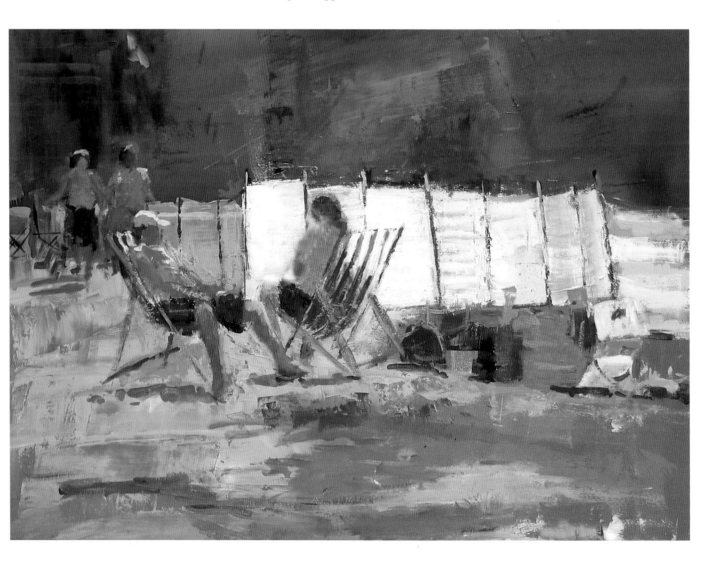

some variety to these elements to counterbalance and avoid monotony.
• Balance larger shapes with smaller ones, contrasting colours with harmonious colours, and textured and busy areas with quieter passages to create a visual equilibrium.
• Unify the painting by introducing a fluid visual rhythm within it – for example, by placing shapes, colours and textures carefully. Unity is the underlying principle that ensures all the elements work together; it makes the painting feel complete.

Finally, as quoted by my wonderful teacher Geoff Crabbe: 'Composition is the careful marshalling of the design elements at our disposal and arranging these to make a symphony that is joyful, inspiring and uplifting. Make it a celebration in paint.'

▽ **London by Night**
40.5 × 56 cm (16 × 22 in)

The strong lines of the café fronts pull the eye towards the area of interest where the figures in the street are. There is a lot of repetition of colour and shape in the painting in order to move the viewer around the picture.

Explore further

• From a piece of cardboard, cut two viewfinders with unusual formats – for example, long and narrow, or square, or simply different from your usual format. Place each viewfinder over a sketch or photograph to find an interesting section, then through a series of thumbnail sketches, work out the best composition prior to painting. This is quite a refreshing exercise, with pleasantly surprising results.

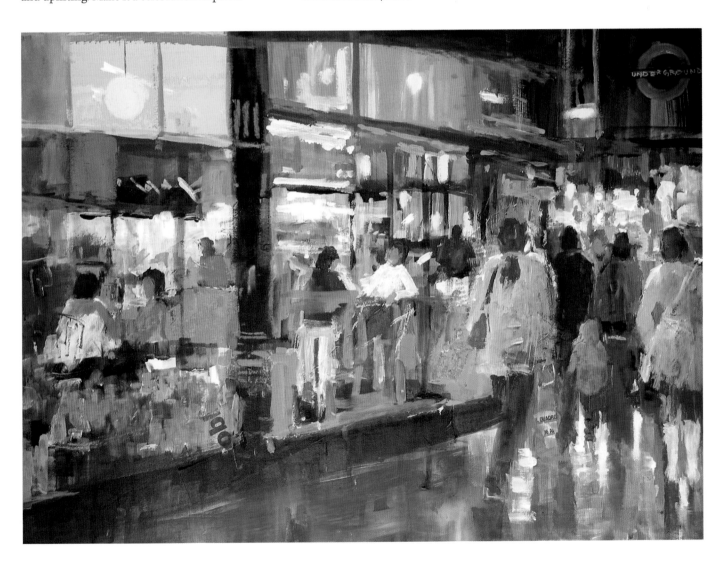

Painting the negative shapes

The subject matter in a painting consists of a series of self-contained and defined shapes. These can be either geometric or organic, and each positive shape is counterbalanced by a negative one – the area between that shape and the adjacent one. No matter how beautifully you have rendered the positive shapes within your painting, any visually awkward and unpleasant negative shapes will result in the failure of the composition. To create dynamic images, just as much attention and emphasis should be given to the negative shapes as the positive ones. An alternative approach is to paint the negative shapes first – I love the magical quality of finding the positive shapes of the subject matter in this way. It feels quite empowering.

When working in transparent water media a considerable amount of pre-planning is needed with regard to the placement of the positive and negative shapes before starting to paint; but with an opaque medium such as acrylics you can overpaint, change and adjust shapes and sizes as you go along, until the painting feels right.

▷ **Moroccan Bazaar**
40.5 × 40.5 cm (16 × 16 in)

This painting started with acrylic ink washes of Flame Orange, Flame Red, Purple Lake and Brilliant Yellow. I let the colours run and once they had dried I started to manipulate the negative shapes to create the figures and the other elements in the painting.

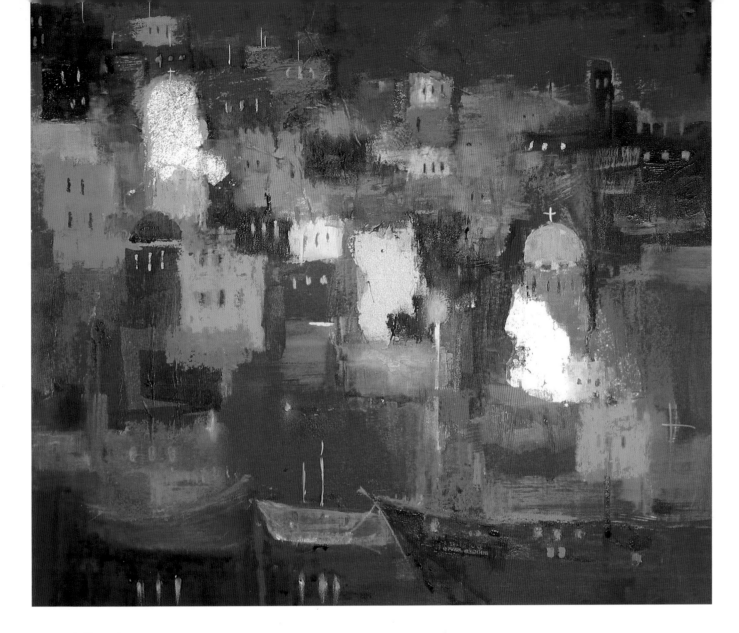

Simplification

There are times when you can be faced with too much information within your subject. Learning to simplify the subject matter is both necessary and a great facility to help you to concentrate on just the important aspects.

Painting *en plein air* can be quite overwhelming, but using a viewfinder is very helpful in assisting you to choose just a section of the landscape to paint. You may have to use your artistic licence to change, move around or leave out aspects of the chosen section to create a balanced and pleasing composition. The urban landscape, in particular, can bombard the artist with information, so it is essential to identify and single out the features that

struck a chord with you at first sight, focusing on those and leaving out the rest. Try eliminating details, but check that by doing so the subject does not lose its significance.

Simplification becomes particularly important once you move towards the abstract – assuming, that is, that you are using recognizable source material as your reference. The best way to construct an abstract image is by breaking down the subject into shapes and then composing with colour and texture. Personally, I like a point of reference for my work and love to paint subject-based pictures. I simplify the subject by focusing on the particular element that excited me and initiated the painting, but I play down the rest by abstracting or semi-abstracting areas of pure texture and colour.

△ **Harbour by Night**
30 × 35.5 cm (12 × 14 in)

Here the hillside village houses have been simplified to create a beautiful pattern. This painting relies on its simplicity for its impact.

Addressing the painting as a whole

To begin with, most artists are too concerned about the individual elements in a painting, tackling these one by one without much thought for the negative shapes and cohesion between the various elements. They tend to spend time busily adding minute and final detail to one part of their painting while other areas of white paper are left unresolved.

The solution is learning to address the painting as a whole. This is achieved by establishing the tonal range right from the start, as this immediately creates unity and harmony throughout the painting.

As a result, all parts of the painting can be worked on at the same time and you will not be left wondering how to deal with areas such as the background, for example. As with other aspects of painting there is no formula. I generally start with the darks and mid tones and work up to the lightest areas, but equally if I feel that a particular painting requires the lightest passages to be in place early on then I start with those.

It is also helpful to begin by establishing a sound composition. Even though a forgiving medium such as acrylics allows you to rectify mistakes later, by thinking about the composition in advance you will find this helps you to address the painting as a whole.

▽ **Irises at Patchings: stage 1**

This initial stage shows how by creating a tonal pattern from the start the whole painting is addressed.

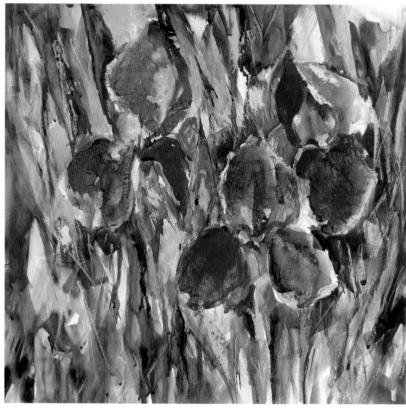

△ **Irises at Patchings**
35.5 × 35.5 cm (14 × 14 in)

The painting was pulled together with a series of negative and positive shapes. Constantly moving from one area to another created harmony throughout the picture and prevented any one area becoming too detailed.

Composing with colour

Colour is the most powerful element in the design of your painting. It has amazingly expressive qualities and sets the overall mood and ambience of the scene. For this reason, great care should always be taken when choosing the most dominant colour in your composition. As the colours in a painting affect each other, the relationship between the pre-eminent colour and the less dominant ones is very important and can have a great impact on the success of your painting. A good way of creating unity in your composition and achieving a good balance between all the colours is by using an underpainting and leaving glimpses visible through the subsequent layers of paint.

Colour plays several other roles in the composition of a painting. Cooler colours in the background and warmer ones in the foreground suggest depth in representational paintings. The same principle of using light and dark and warm and cool colour contrasts creates movement in abstract paintings. Complementary colours placed next to each other really sing out and when repeated through the painting create a rhythmic pattern. Remember that ultimately you are aiming for a balance of high-key and subtle tones as well as complementary and harmonious colours.

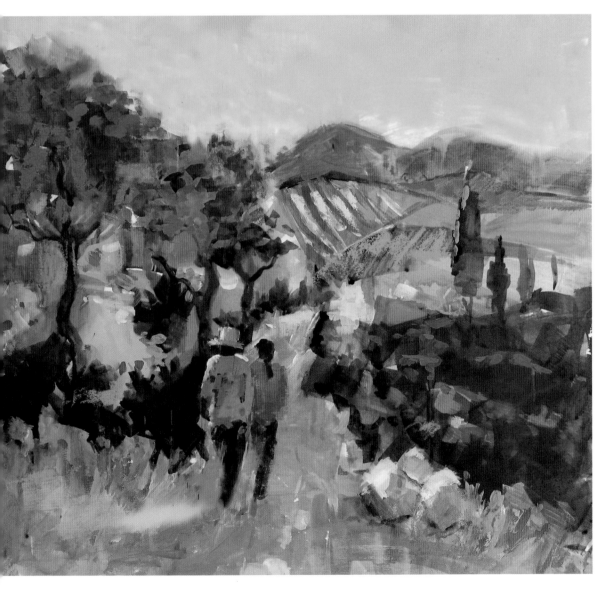

◁ **Provence Landscape**
40.5 × 40.5 cm (16 × 16 in)

The yellow underpainting here creates unity within the painting. Complementary colours evoke a warm atmosphere, while repeated dabs of colour lead the eye around the painting.

Still life

Painting still life is undoubtedly an invaluable practice for the artist, in which the relationship of various shapes and forms can be explored at leisure without the fear or distraction of external influences, such as changes of weather or light. In this particular genre the artist has optimum control over the design element of the painting.

Although traditionally still life paintings feature a number of related objects, you should not overlook the beauty of a single item, dramatically lit for maximum impact. You can set up a still life specifically, but the best still life paintings generally include a collection of objects which have grouped together naturally to form an interesting design. Garden corners often provide random still life subjects such as this. Indeed, some artists prefer found still life arrangements to ones that have been formally set up. Even a collection of the most mundane and ordinary objects can become a potential subject for a still life painting, and as we are surrounded by them in our day-to-day life, painter's block should become a thing of the past!

The way in which your still life is lit, either by natural light or an artificial light source, will also teach you valuable lessons about colour balance and, most importantly, tonal values.

◁ **Still Life with Poppies**
56 × 46 cm (22 × 18 in)

I started this still life by applying washes of Process Magenta and Turquoise ink. I then picked out certain patterns and enhanced them with oil and wax pastels. Heavy-body acrylics were used to create the shapes of the flowers, and wax pastel to highlight the leaves.

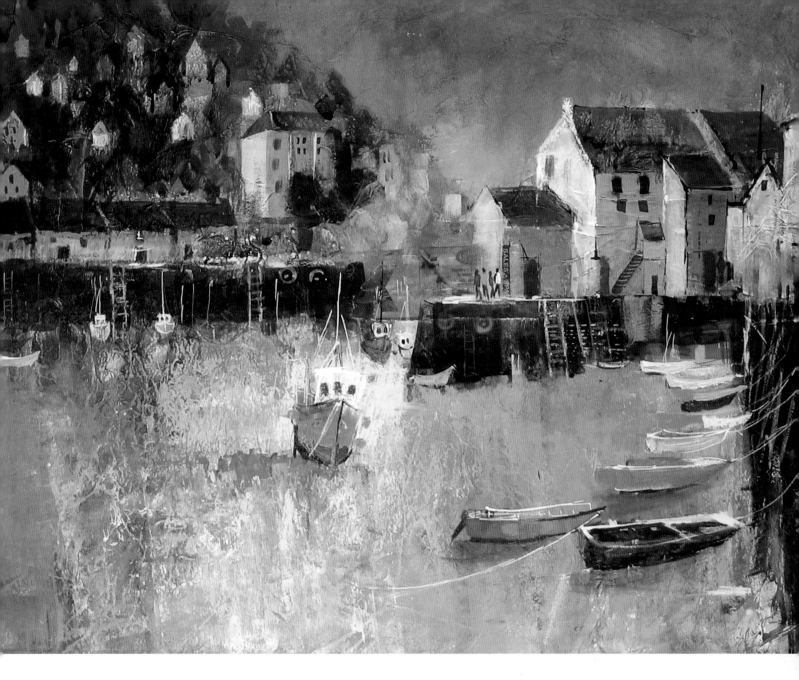

Harbours

Harbours are among the most popular painting subjects. They include numerous interesting and complicated shapes to keep the artist happy, but because of all the different elements involved a strong and carefully structured composition is particularly important.

Most harbours include a variety of buildings, shop fronts, cafés, cars and crowds walking along the quay, not to mention, of course, boats, a jumble of masts, water and reflections. A degree of simplification is usually necessary so that you do not confuse the viewer. Boats are fascinating subjects in themselves, but their shapes can be difficult to capture, especially if they are foreshortened. Practise drawing them separately before incorporating them into a painting.

The quality of light often evident on the coast can make harbours magical places for the artist. Acrylic inks are particularly good for setting the scene, suggesting the background, water and reflections, and for capturing the mood in harbour paintings; while thicker paints can help to portray texture and details, such as boats, walls, ropes, lobster pots and other harbour paraphernalia.

△ **Polperro at Low Tide**
46 × 56 cm (18 × 22 in)

I applied tissue paper over the whole area to create a textured surface and then added washes of Raw Sienna and Marine Blue acrylic ink. I used an old credit card to establish the lines of the buildings and harbour walls. The painting was finished with heavy-body acrylics and dabs of oil and soft pastels.

DEMONSTRATION White Poppies

It is good practice to tackle a painting by working on both the positive and the negative shapes. Although this should apply to any subject matter, there are some which force the issue: white flowers or objects are a prime example. Acrylics give you the choice of either saving the white of the paper or using Titanium White to paint the white areas, or combining both approaches.

Colours used

Water-soluble wax crayons: Turquoise Blue, Dark Ultramarine Blue
Acrylic inks: Prussian Blue, Purple Lake, Indigo, Lemon Yellow, Payne's Grey, Process Magenta
Oil pastels: Lime Green, Purple

Stage one

I used Turquoise Blue water-soluble wax crayon on watercolour paper to put in the simplest outline of the flowers. I wetted the paper lightly up to the edge of the flower heads, then flooded in washes of Prussian Blue, Purple Lake and Indigo acrylic ink, letting the colours merge into each other. Before the Prussian Blue and Indigo dried I dropped in some Lemon Yellow acrylic ink to mix some varied light and dark greens on the paper. This created a series of soft and hard edges. I let these initial washes dry completely.

◁ Stage one

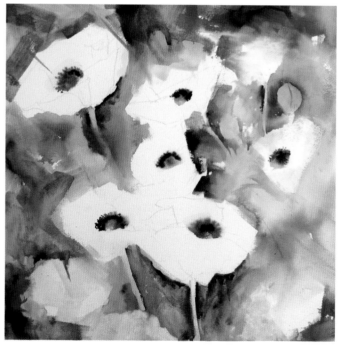

Stage two

In the top right-hand corner I noticed a small, round, incidental shape, created as a result of the first washes, and by wetting the area around it and flooding in Prussian Blue acrylic ink I turned this into a bud. In the same way, I found the stems for a few of the flowers. I defined the centres of some of these by wetting the area and dropping in Purple Lake and some Payne's Grey acrylic ink. Again I let the painting dry completely.

▷ Stage two

Stage three

I completed the remaining flower centres and added neat Indigo acrylic ink behind some of the flower heads to make them stand out. I put in some distant flower heads by wetting flower-shaped areas and flooding in some Prussian Blue acrylic ink, leaving lighter areas in the middle and then adding the dark flower centres. The flowers painted in this way recede and give the painting depth. I also painted a few negative shapes to create more buds and some foliage.

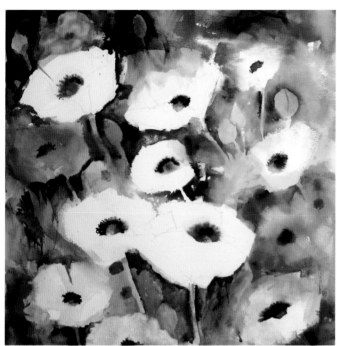

◁ Stage three

Stage four

With a mix of Process Magenta and Purple Lake acrylic ink I gave the petals some shadow colour to define their shape and differentiate between them. I also highlighted the buds with Lime Green oil pastel. I then applied a few strokes of Dark Ultramarine Blue water-soluble wax crayon to lift some of the dark areas of the painting. I found a few more flower heads in the background to create even more recession. Finally, I added a few tiny dabs of Purple oil pastel in the centre to finish the painting.

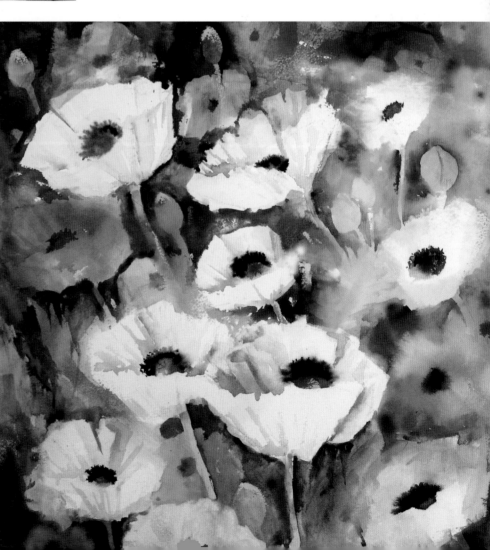

▷ White Poppies
38 × 38 cm (15 × 15 in)

OTHER VIEWPOINTS

A sound compositional arrangement can turn the most ordinary subjects into beautiful works of art. Conversely, the most interesting subject can fall apart without a balanced compositional structure. Studying paintings with a strong sense of design, such as those featured here, will help you to develop your own compositional skills.

▷ **Seated Figure**
SUSAN KIRKMAN
50 × 70 cm (19¾ × 27½ in)

There is a great sense of balance in this composition. The larger figure is balanced by the similar smaller shape. The blue-grey colour scheme provides harmony, but the dab of complementary orange prevents monotony. A myriad of horizontal, vertical and oblique lines keeps the viewer fully engaged with this dynamic composition.

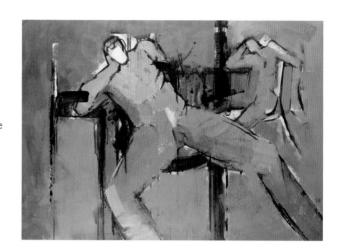

▷ **After Dinner at Dedham**
LIZ SEWARD RELFE
51 × 51 cm (20 × 20 in)

Here Liz has taken advantage of a group of related objects which have collected over the course of dinner, a fine example of a found still life arrangement. Overlapping the various objects links them together, while the repetition of curves creates a flowing and rhythmic pattern through the painting.

◁ **Hellebores**
ANN BLOCKLEY
36 × 35 cm (14¼ × 13¾ in)

In this painting the white of the paper has been preserved for the petals and the flower heads have been created by painting the background, or the negative shapes, around them. There are many interesting shapes within the background washes of colour.

△ **Salisbury Market**
GEOFF CRABBE
60 × 75 cm (23½ × 29½ in)

Attention to detail in the foreground figures is counterbalanced by less definition in the more distant elements, which creates depth. There is a healthy balance of detail and simplification in this delightful depiction of Salisbury market.

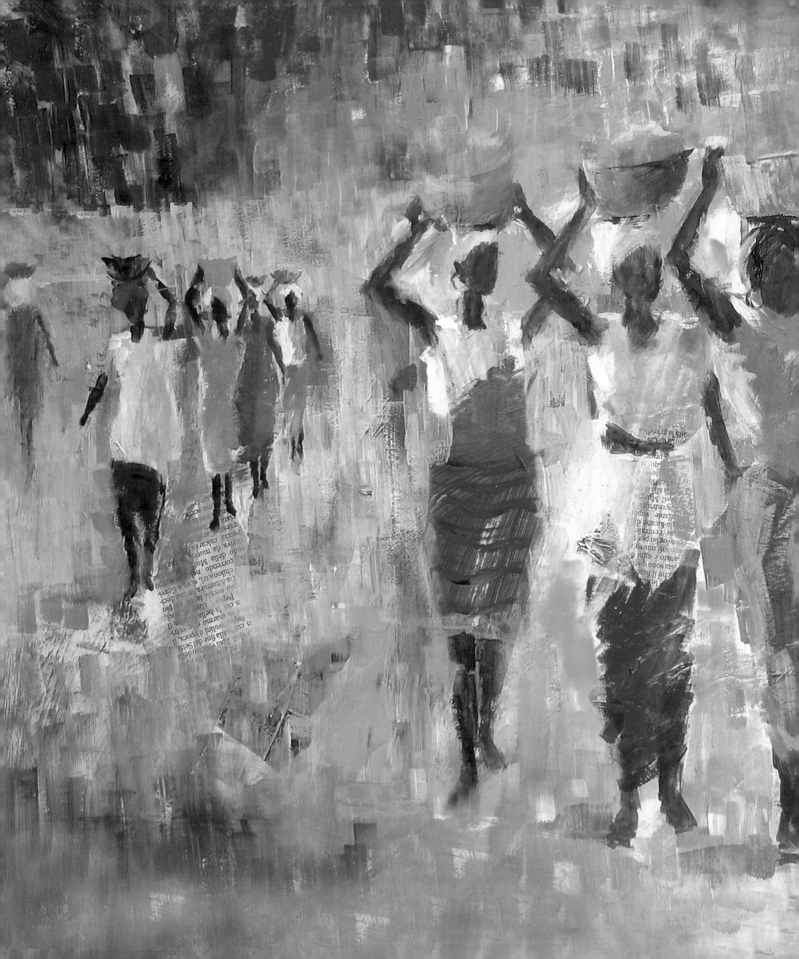

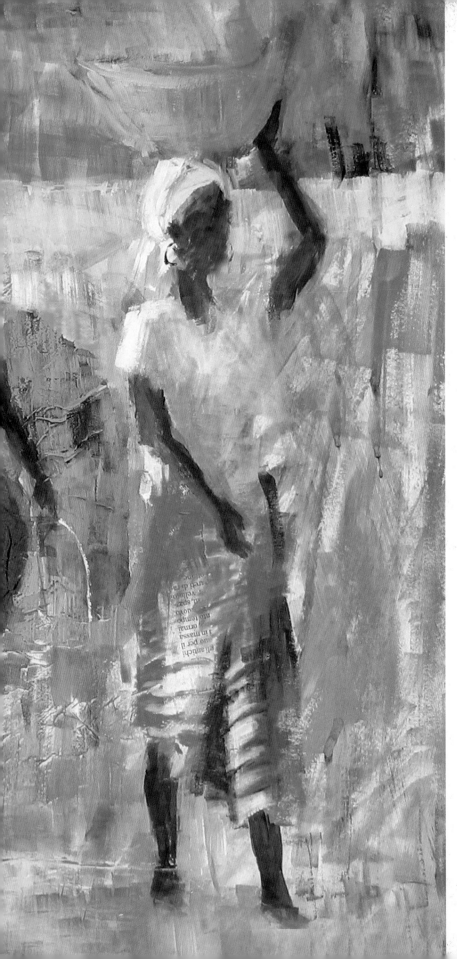

Movement and rhythm

Movement and rhythm are two of the major principles of design. They work together to invite viewers into a picture, enticing them to travel around the painting to the focal point and on to other interesting areas. While some paintings convey a feeling of calm and tranquillity, most subjects benefit from the energy created through movement and a rhythmic arrangement. The expressive quality of paintings with a sense of movement and rhythm provides an exciting and stimulating visual flow for the observer.

In this chapter we will look at a few ways in which you can employ acrylic colours to breathe a sense of life and vitality into your paintings.

◁ African Girls
46 × 56 cm (18 × 22 in)

Movement and energy

An important element in dynamic images is the energy that is generated by creating a sense of movement. Movement in a painting is both a path for the viewer's eye to travel and the means by which a sense of motion and action is implied. As an example, linear marks indicating the lines of a footpath or river draw the viewer into the painting and towards the focal point. As a rule, oblique lines are more dynamic than placid horizontal ones.

When a painting includes living creatures a sense of movement often becomes an inherent part of the subject. To portray this convincingly, however, requires careful observation of the shapes adopted by figures, animals and birds while in motion. Sporting figures often assume unstable and off-balance positions as they move. The torsos of fast-moving animals become quite narrow and elongated when they are running, while in the case of a large animal, the position of its legs is a good indication of movement. The rapid beating of a bird's wings can be captured by blurring the colours of the wings and losing some of the edges to create an out-of-focus effect.

Objects such as trains, cars and bicycles do not change their shapes when in motion. A trail of smoke on top of a train or a puff of dust behind a car are both ways of indicating movement. At high speed cars and bicycles lose their definition, so painting them with minimum detail and blurring the background by smudging the colours will effectively imply motion.

Acrylics offer useful techniques such as the dry-brush technique, scumbling, broken colour and impasto for depicting a sense of energy and movement. The opacity of acrylics allows you to rework, overpaint and change the position of moving components in a painting so there is little or no need for any forward planning.

▽ **Sunset Joggers**
24 × 38 cm (9½ × 15 in)

The boy's body is totally off balance as his weight is pushed forward by his left leg, and it has assumed an oblique line. The dog's torso, on the other hand, has adopted an elongated pose. Splashes of water add to the energy and the sense of movement.

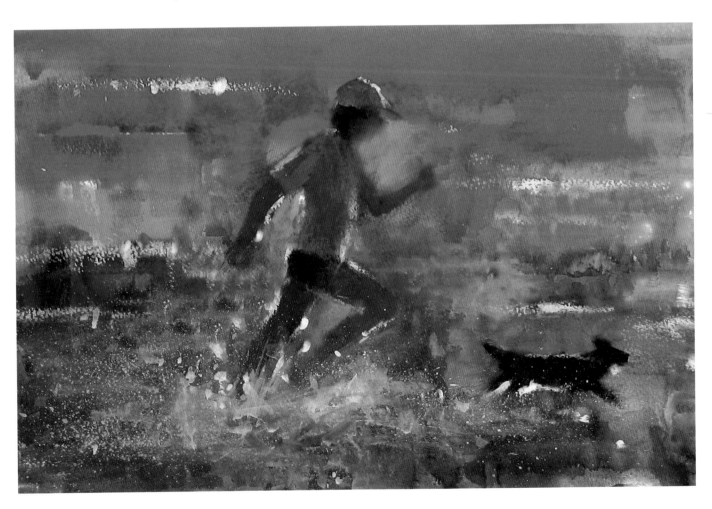

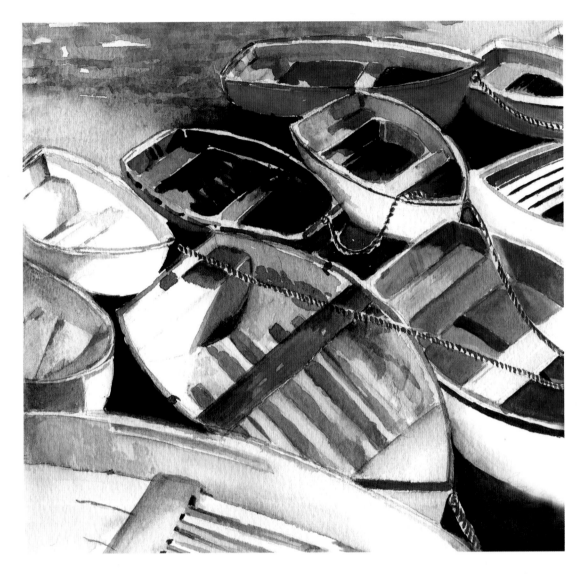

◁ **Boatyard**
25.5 × 25.5 cm (10 × 10 in)

Here the repetition of the boat shapes creates a perfect rhythmic pattern to enable the viewer to move around the painting. The curved lines of the boats echo throughout the composition and unify the image.

Creating rhythm

Rhythm is the unifying factor in painting, like the beat or tempo in a musical arrangement, leading the eye of the viewer from one element to the next around the picture. It can be created by the repetition of line, shape, colour, tone or texture throughout the painting. Juxtaposing harmonious and complementary colours, contrasting the tonal values, echoing shapes and edges, and repeating texture and pattern are all ways of introducing a rhythmic arrangement in a painting. Be aware, however, that if the repeated elements are too similar the resulting picture can become boring, so to ensure a more dynamic image, bring variety to all the elements you include. For example, make some lines longer or shorter and vary the size of certain areas of texture or colour.

Rhythm can be fluid and smooth or more erratic and energetic. Aim to make your viewer move to the beat and rhythm of your brush marks. As your experience grows you will begin to achieve this naturally and instinctively in your work.

Studio tips

- Gestural figure drawing using a stick and ink is a great way of learning how to portray a sense of movement in your work.

Painting figures

Figures not only animate a painting and create a narrative but also provide an element of scale within a landscape. It is important to get their proportions correct – over-familiarity with the subject can sometimes lead to incorrect assumptions about these. Careful observation and regular practice in life classes will help you to paint convincing figures. Remember that the proportions of the average adult figure is seven heads high, whereas in children this reduces to just four heads high. If you get an adult's proportions wrong you may make the figure look child-like and unnatural; likewise, children should not be portrayed as mini-adults.

Too much precision and attention to detail can result in wooden and static figures, so avoid outlines and do not over-emphasize their shapes – let them happen with as few brush strokes as possible. When painting groups of figures some interaction between a few of them will create more interest for the viewer. With acrylics there is plenty of scope for changing and reworking your figures until they sit comfortably within the painting.

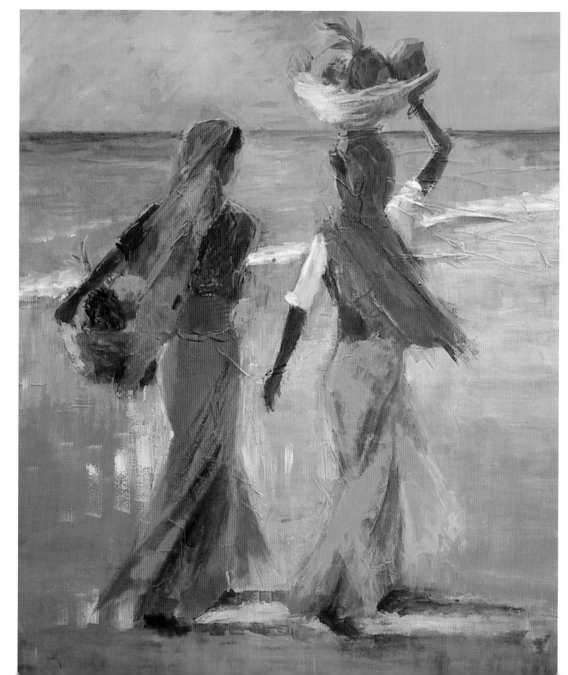

▷ **Seashore Fruit Sellers**
51 × 40.5 cm (20 × 16 in)

I wanted to achieve a certain liveliness in this painting with the interaction of the two figures. A sense of movement is created not just by the position of the arms and legs but also by the colourful flowing garments.

Crowd scenes

Crowd scenes provide ideal scenarios for implying a sense of movement and rhythm in a painting. Street views and townscapes, markets and beaches are just some examples of subjects in which crowds of people feature. These are rather difficult to paint from life as they usually consist of transient moments, so this is an occasion when photographic reference becomes a particularly useful tool.

When painting crowd scenes, use a dominant colour scheme for the people to provide a feeling of unity, but also highlight a few of the figures by painting them in different colours or emphasizing an item of clothing, such as a patterned shirt or a hat. When choosing which figures to pick out, bear in mind the classic compositional guidelines and ensure that they form a diagonal pattern or a triangle so that they will encourage the viewer's eye to travel round the picture in a dynamic line. By varying your figures in this way you will prevent your painting becoming either too busy or too lacking in interest.

In street scenes it is more effective to include groups of people with just a few isolated figures here and there, rather than lots of single ones. Remember that the head heights will vary according to your eye level or the horizon line: if you are looking down at the crowd, the figures will be below your eye level and therefore will be lower on your painting surface; if you are looking up at the crowd, then they will be above your eye level and will be higher up.

◁ London Crowd, Trafalgar
40.5 × 40.5 cm (16 × 16 in)

The positions of the figures' legs in this street scene imply movement. I used a darker tone of grey to make a triangular pattern within the crowd. Accents of Magenta and Cadmium Orange heavy-body acrylics create a dynamic diagonal path through the painting.

Movement in nature

Movement in nature is a result of elemental forces such as wind and rain. In a landscape painting a strong wind or a gentle breeze can be suggested by the way in which trees, tall grasses and clouds are portrayed. On blustery days and in heavy storms trees bend in the direction of the wind, the grass becomes flattened and clouds assume elongated shapes. Including some figures with their hair and clothing blowing in the wind can also help to suggest movement in a painting.

Depicting movement in water scenes is great fun. Acrylic paint, with its varied consistencies, is the ideal medium for capturing the effects of moving water, and white acrylic ink can be particularly useful, especially if it is dripped on to your painting or applied in random streaks. Thicker white paint is perfect for the rushing water around scattered rocks on a river bed. When painting waterfalls, include a very dark background as a contrast to the white foaming water. For fast-flowing rivers a muddy brown or dark olive-green provides a good base colour. The continual movement of the sea surface creates a myriad of shapes and patterns, repeated in a rhythmic arrangement. Applying short strokes of broken colour is an effective way of portraying this sense of ceaseless motion.

▽ **Afternoon Sun**
38 × 40.5 cm (15 × 16 in)

In this seascape I took advantage of Titanium White acrylic to re-create the foaming effect of the waves, using the spattering technique. White acrylic ink was used for the splashes of water.

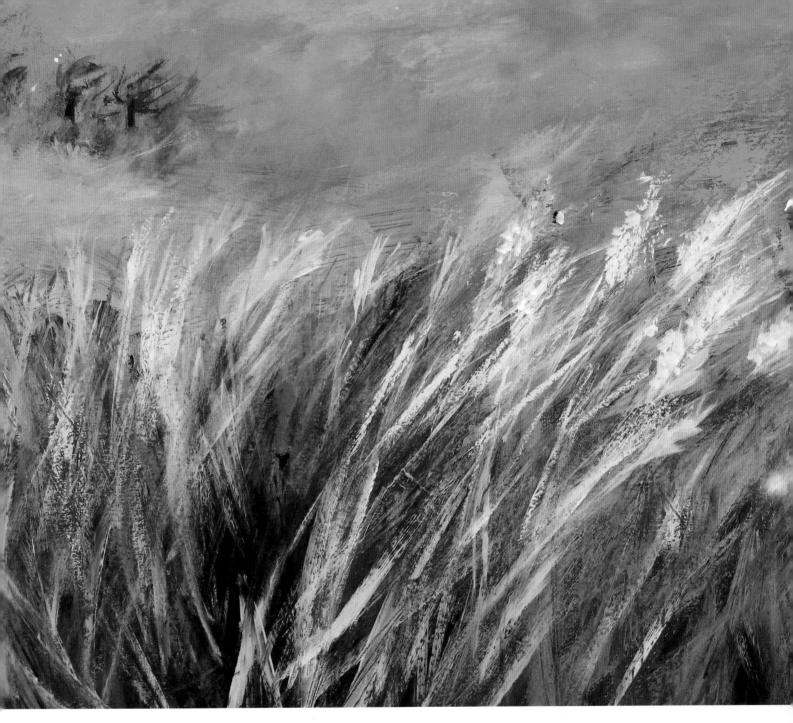

△ Windblown Grass
30 × 40.5 cm (12 × 16 in)

I applied an underpainting of
Burnt Sienna and Titanium
White, and a mix of Prussian
Blue and Burnt Sienna for
the darker parts of this
painting to add depth. I then
used Buff Titanium and the
dry-brush technique to paint
the tall grasses, bent in the
direction of the wind.

Explore further

- Paint the same landscape or seascape once in a calm
 state and once in windy and stormy conditions.
- Paint a picture which includes moving subjects, such
 as sporting figures, where you can imply a sense of
 motion. Then choose a different subject and create
 movement by arranging a rhythmic pattern through
 the repetition of colour, tone and shapes.

DEMONSTRATION Cornish Surfers

When painting subjects that include figures it is absolutely vital to convey a sense of movement. In the case of a seated and still figure this can be created through lively and painterly brush marks, and by including animated features. It is somewhat easier, however, to suggest movement when the figures are in motion, either walking, running or engaged in some kind of sporting activity, as in this demonstration.

Colours used

Water-soluble wax crayon: Sanguine
Acrylic inks: Prussian Blue, Red Earth, White
Heavy-body acrylics: Ultramarine Blue, Titanium White, Burnt Sienna, Cadmium Orange

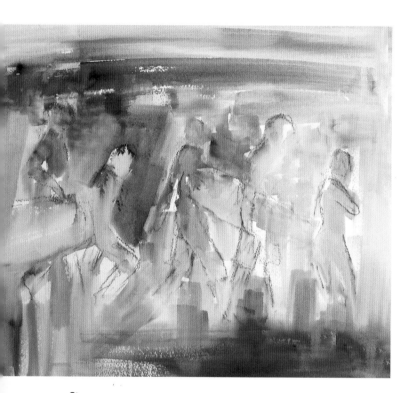

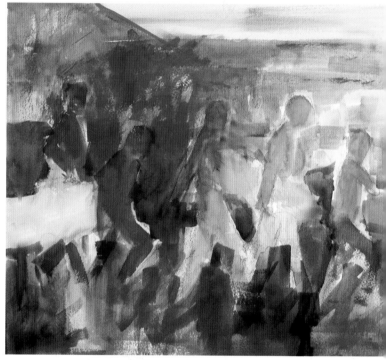

Stage one
With the Sanguine water-soluble wax crayon I drew simple outlines of the figures on to watercolour paper. I then added an overall wash of diluted Prussian Blue acrylic ink. This slightly smudged the figures' outlines, but left enough information to indicate their positions. I left this to dry completely.

Stage two
With a mix of Ultramarine Blue and Titanium White heavy-body acrylics I painted the distant hills. I added darker washes of Prussian Blue acrylic ink in the foreground to prepare it for the lighter colours to be applied on top later. Then I added the flesh tones of the figures with varying washes of Red Earth acrylic ink.

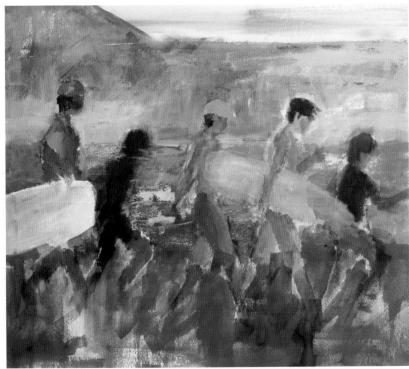

Stage three

With a mix of Ultramarine Blue and Burnt Sienna heavy-body acrylics I painted the heads and the two smaller silhouetted figures. I added a tint of Ultramarine Blue heavy-body acrylic to the central figure's cap and the left-hand figure's shirt. I added a warm grey mix of Burnt Sienna, Ultramarine Blue and Titanium White to the surfboards and the sea. I used Cadmium Orange for the shorts of the second figure from the right and for the cap of the far-left figure to take the eye across the painting.

Stage four

I decided to alter the position of the arms of the two central figures to a more sympathetic angle, and then put the finishing touches to the figures. With Titanium White I added highlights to the surfboard and the central figure's cap. I blurred some of the edges between the water and the figures by scumbling the paint to reinforce a sense of motion. Finally, I enhanced the movement of the water by spattering White acrylic ink with a toothbrush.

△ Stage three

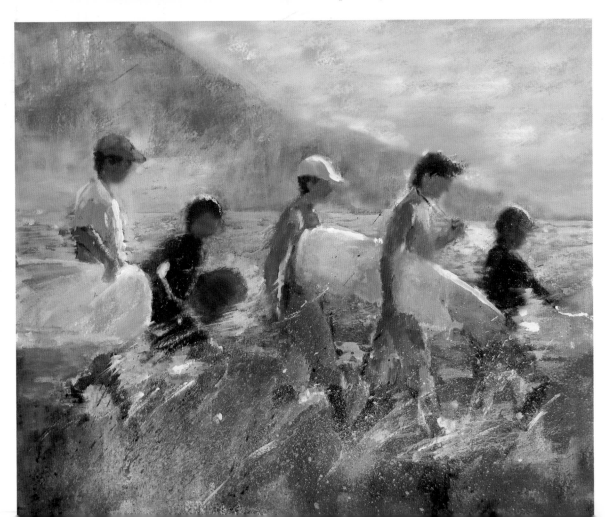

▷ Cornish Surfers
35.5 × 40.5 cm
(14 × 16 in)

OTHER VIEWPOINTS

Here I have selected the work of four artists with quite diverse styles and subject matter to show just a few of the many ways you can introduce a sense of movement and rhythm to enliven your painting. These paintings clearly demonstrate that the subject need not necessarily consist of live or moving components to convey movement.

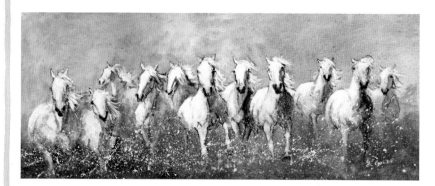

◁ **Carmargue Horses**
ROSEMARIE DE GOEDE
20 × 51 cm (8 × 20 in)

The success of this painting is as much about what Rosemarie has eliminated as what has been left in. The spattering of white ink enhances the sense of energy and the speed of the galloping horses.

▽ **Mousehole Harbour**
MIKE BERNARD
76 × 102 cm (30 × 40 in)

By rhythmic repetition of the cottages Mike has cleverly created an incredible visual flow through this painting of otherwise very solid and grounded elements.

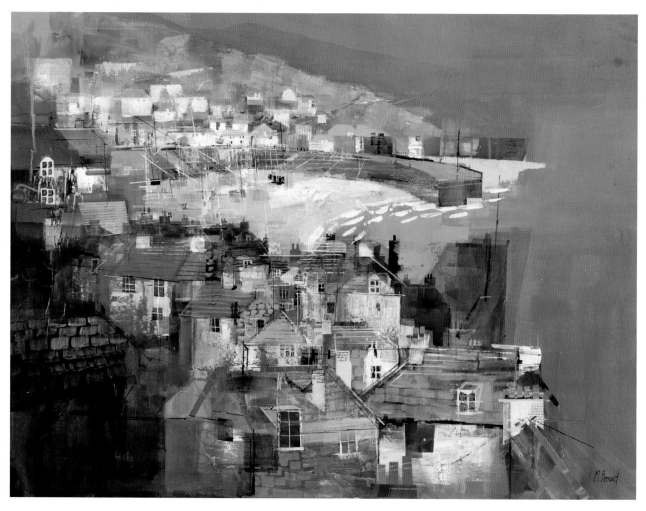

△ **The Reader**
SUSAN KIRKMAN
76 × 51 cm (30 × 20 in)

The vigorous brush marks, surface texture, dribbles of paint and strong oblique lines give this seated and still figure a sense of life and vitality.

▷ **The Passionate**
SERA KNIGHT
35 × 25 cm (13¾ × 9¾ in)

The echoing of the energetic brush marks creates a wonderful sense of movement in this beautiful painting of a dancer. At the same time the fluid lines and the cool colour scheme give it a certain feeling of calm and serenity.

Last thoughts

The process of creating a piece of artwork is rather like solving a puzzle: the answers already exist and the gratification comes from finding them. Too often in my workshops I come across students who opt to copy mindlessly other artists' work, rather than fully engage in the creative process of painting. This is rather like solving a puzzle with the answers in front of you. The main culprits responsible for this approach are lack of confidence, low self-esteem and fear of failure. There is a clear line between being inspired by another artist's work and copying it outright, and there is certainly no artistic merit in the latter. There are of course copyright implications to contend with as well.

We are lucky to live in an age with a wealth of inspiring art movements behind us to draw from; in fact, there are probably few truly new ideas left to explore. However, by using our imagination and some hard graft it is still possible to bring together previously existing concepts in an original way.

Commitment and passion are two vital ingredients for a working artist as your whole life revolves around painting. You have to be able to ride through the times when the river of inspiration runs dry as well as enjoying the heady highs of success while keeping your feet firmly on the ground. I hope this book has given you some insight into the wonderful medium of acrylics and has inspired you to find your own unique artistic voice. The ability to experiment and to gain valuable experience from any mistakes is the hallmark of a truly successful and creative artist. In the words of the American novelist Herman Melville: 'It is better to fail in originality than to succeed in imitation.'

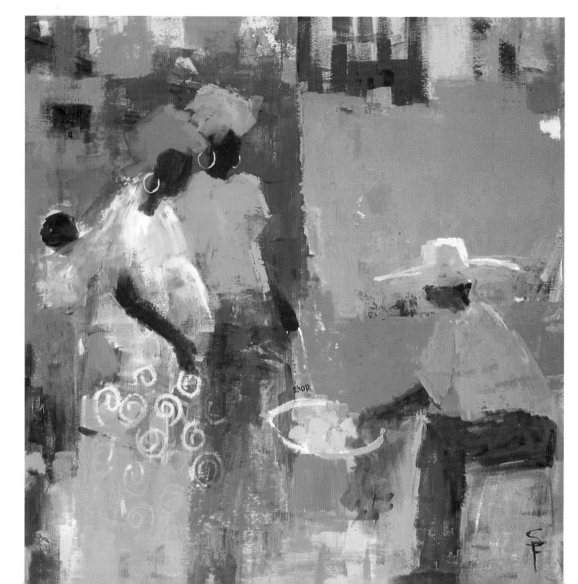

▷ **Craving Lemons**
38 × 37 cm (15 × 14½ in)

This is purely my interpretation of what I experienced in a Caribbean fruit market – sheer indulgence in playing with the complementary and harmonious colours.

Taking it further

There is a wealth of further information available for artists, particularly if you have access to the internet. Listed below are just some of the organizations or resources that you might find useful to help you to develop your painting.

ART MAGAZINES

The Artist, Caxton House, 63/65 High Street, Tenterden, Kent TN30 6BD; tel: 01580 763315
www.painters-online.com
Artists & Illustrators, 26-30 Old Church Street, London SW3 5BY; tel: 020 7349 3150
www.artistsandillustrators.co.uk
International Artist, P. O. Box 4316, Braintree, Essex CM7 4QZ; tel: 01371 811345
www.international-artist.com
Leisure Painter, Caxton House, 63/65 High Street, Tenterden, Kent TN30 6BD;
tel: 01580 763315
www.painters-online.com

ART MATERIALS

Daler-Rowney Ltd, P. O. Box 10, Bracknell, Berkshire RG12 8ST; tel: 01344 461000
www.daler-rowney.com
Winsor & Newton, Whitefriars Avenue, Harrow, Middlesex HA3 5RH; tel: 020 8424 3200
www.winsornewton.com

ART SHOWS

Affordable Art Fair, Sadler's House, 180 Lower Richmond Road, Putney Common, London SW15 1LY;
tel: 020 8246 4848
www.affordableartfair.com
Art in Action, Waterperry House, Waterperry, Nr Wheatley, Oxfordshire OX33 1JZ;
tel: 020 7381 3192 (for information)
www.artinaction.org.uk
Patchings Art, Craft & Design Festival, Patchings Art Centre, Oxton Road, Calverton, Nottinghamshire NG14 6NU; tel: 0115 965 3479
www.patchingsartcentre.co.uk

ART SOCIETIES

National Acrylic Painters' Association, 134 Rake Lane, Wallasey, Wirral, Merseyside CH45 1JW; tel: 0151 639 2980
www.napauk.org

Society for All Artists (SAA), P. O. Box 50, Newark, Nottinghamshire NG23 5GY;
tel: 01949 844050
www.saa.co.uk
Society of Women Artists, 1 Knapp Cottages, Wyke, Gillingham, Dorset SP8 4NQ;
tel: 01747 825718
www.society-women-artists.org.uk

BOOKCLUBS FOR ARTISTS

Artists' Choice, P. O. Box 3, Huntingdon, Cambridgeshire PE28 0QX; tel: 01832 710201
www.artists-choice.co.uk
Painting for Pleasure, Readers' Union, Brunel House, Forde Close, Newton Abbot, Devon TQ12 4PU; tel: 0870 4422033
www.readersunion.co.uk

INTERNET RESOURCES

Artcourses: an easy way to find part-time classes, workshops and painting holidays
www.artcourses.co.uk
British Arts: useful resource to help you to find information about art-related matters
www.britisharts.co.uk
Fairground Craft & Design Centre: complex of artists' studios, including Soraya French's studio, a gallery and restaurant
www.fairgroundcraft.co.uk
Galleries: the UK's largest-circulating monthly art listings magazine, with details of exhibitions and other art services
www.artefact.co.uk
Galleryonthenet: provides member artists with gallery space on the internet
www.galleryonthe.net
Golden Artist Colors: professional-grade acrylic paints and materials
www.goldenpaints.com
Liquitex Artist Materials: high-quality acrylic art materials
www.liquitex.com
Open College of the Arts: an open-access college, offering home-study courses to students worldwide
www.oca-uk.com
Painters Online: interactive art club run by The Artist's Publishing Company for amateur and professional artists
www.painters-online.com

RA Magazine: a quarterly magazine published by the Royal Academy, covering the latest developments in the arts
www.royalacademy.org.uk/ra-magazine
Soraya French: the author's website, with details of her exhibitions, workshops and painting holidays, and a gallery of her work
www.sorayafrench.com

VIDEOS/DVDs

APV Films, 6 Alexandra Square, Chipping Norton, Oxfordshire OX7 5HL; tel: 01608 641798
www.apvfilms.com
Teaching Art, P. O. Box 50, Newark, Nottinghamshire NG23 5GY; tel: 01949 844050
www.teachingart.co.uk
Town House Films, Norwich Business Park, Whiting Road, Norwich NR4 6DN;
tel: 01603 281007
www.townhousefilms.com

FURTHER READING

Bellamy, David, *Painting Wild Landscapes in Watercolour*
Blockley, Ann, *Flower Painting Through the Seasons*
 Watercolour Textures
Crawshaw, Alwyn, *30-minute Sketching*
 Ultimate Painting Course
Evans, Margaret, *30-minute Pastels*
French, Soraya, *30-minute Acrylics*
Jennings, Simon, *Artist's Little Book of Colour*
 Collins Artist's Colour Manual
 Collins Complete Artist's Manual
Peart, Fiona, *30-minute Watercolours*
Reiter, Laura, *Learn to Paint Abstracts*
Soan, Hazel, *Artist's Little Book of Inspiration*
 Secrets of Watercolour Success
Talbot-Greaves, Paul, *30-minute Landscapes in Watercolour*
Trevena, Shirley, *Vibrant Watercolours*
Waugh, Trevor, *30-minute Flowers in Watercolour*
 30-minute People in Watercolour
Whitton, Judi, *Loosen up your Watercolours*
Wilkins, David G. (General Editor), *Collins Big Book of Art*

For further information about Collins books visit our website: **www.collins.co.uk**

Index

Page numbers in **bold** refer to captions